DERBY AT WORK

PEOPLE AND INDUSTRIES THROUGH THE YEARS

MAXWELL CRAVEN

AMBERLEY

For Cornelia, who was at work throughout the writing of this book

First published 2017

Amberley Publishing
The Hill, Stroud
Gloucestershire, GL5 4EP

www.amberley-books.com

Copyright © Maxwell Craven, 2017

The right of Maxwell Craven to be identified as the
Author of this work has been asserted in accordance
with the Copyrights, Designs and Patents Act 1988.

ISBN 978 1 4456 7009 6 (print)
ISBN 978 1 4456 7010 2 (ebook)

British Library Cataloguing in Publication Data.
A catalogue record for this book is available
from the British Library.

Origination by Amberley Publishing.
Printed in the UK.

CONTENTS

ACKNOWLEDGEMENTS

This modest book draws on material from my *Derby, an Illustrated History* (Breedon Books, 1988, 2nd rev. edn 2007) and also on my *John Whitehurst: Innovator, Scientist, Geologist and Clockmaker* (Fonthill Publishing, 2015), and the full roll call of all those who have helped and encouraged me on my way to getting something like a hold of Derby's history are fully acknowledged therein. Regrettably, several of them are now, no longer with us, including Derek Buckley, Frank Scarratt, Roy Hughes, Don Farnsworth, Winnie Moore and Olga Fraser, photographs from the collections of or by whom appear in this book and are gladly acknowledged.

Having spent twenty-five years of my life working at Derby Museums (and much more recently, five years as a board member of the Derby Museums Independent Trust), I have been fortunate in having had much help from both directors and members of staff there past and present, and I am particularly grateful to the Trust's executive director, Tony Butler, to Jonathan Wallis and others, especially in respect of being able to share elements of their incomparable photographic collection with a wider audience. Likewise, much of the information redeployed herein was gleaned from the archives of Derby's excellent Local Studies Library, and I am most grateful to librarians and assistants past and present for their help, which is always much appreciated.

In conclusion, I cannot pass Amberley Publishing for their seemingly insensate desire to persuade me to write them books on an almost annual basis. They are largely easy to please, while their products are attractively produced and, one hopes, entertaining. To my wife Carole, too, I owe a big debt of thanks for bearing with me during the processes of research and production in addition to driving me around so that I might take the appropriate photographs. Also to my student daughter, Cornelia, who, when having to write assignments in her vacations, likes someone to sit with her to encourage productivity. In that way, we fuel each other's output.

INTRODUCTION

D erby has a history that spans some 2,000 years, yet perceptions of it, especially in the context of industry, have changed. Daniel Defoe characterised it as 'A town of gentry rather than trade', yet the general view of it when I first announced I was going to live there in 1966 was that it was very much an industrial town. Indeed, a striking aspect of one's arrival was the sight of all its fine buildings blackened by soot. It was then dominated by the vast railway works, nationalised and in decline, and by Rolls-Royce, perceived as the jewel in Britain's industrial crown. Both were supported by a flock of foundries kept afloat by subcontract work. Yet within a decade, Rolls-Royce (invariably referred to as 'Royce's' in Derby) had gone into receivership and had been, perhaps ironically, nationalised by Edward Heath's government. But within two more decades railway engineering was in full retreat; the foundries were closing at an alarming rate and the future of industry in Derby (which had by this time received the accolade of city status by a royal warrant, which coincided with the 1977 Silver Jubilee) was in considerable doubt. That the position has recovered so impressively since then says much about the enterprise, resilience and (at times at least) confident leadership displayed by Derby's citizens, workforce, business leaders and politicians, backed up at crucial moments by support from central government.

Writing about Derby's industries – Derby 'at work' – within the compass of a short book like this is, however, a challenge. One could, for instance, extend 'at work' to all remunerated callings, but Derby's industries have been so numerous and dynamic that such an attempt would have required three times as many pages. Furthermore, it is the industries that single Derby out as distinctive, and it is upon them that this book attempts to concentrate, from which it is not too difficult to deduce that much has had to be omitted. What remains is what I consider most important.

Even in Roman times, the small town of Derventio, which had grown out of a redundant military fort on the east bank of the Derwent at its lowest crossing point, had something of an industrial focus, with the manufacture of simple pottery ('Derbyshire Ware') and the processing of the lead recovered from mines further north in the Peak. Just as the Roman settlement was followed by something of a hiatus in terms of urban settlement, so we lose sight of any form of industrial activity for some centuries. The settlement that grew up afresh, three quarters of a mile to the south of Derventio, which we now call Derby, came into existence after the Christianisation of the Anglian kingdom of Mercia after the death of its last pagan king, Penda, in 654. At some date before the early eighth century, a minster church was

established to evangelise the Germanic population of the region, and after AD 800 it seems to have been dedicated to the Northumbrian royal martyr-saint, Ahlmund (Alkmund), reflecting the political dominance that Northumbria occasionally enjoyed over Mercia, at least prior to the reign of Mercian King Aethelbehrt. This church was collegiate, in that it was served by a superior and six canons, or missionary priests, and it attracted a small settlement around it to cater for the needs of the clergy, returning simple craft occupations to the urban context on the future site of Derby.

It was long thought that at this time Derby was called Northworthy, but after close analysis of Domesday Book by Dr David Roffe in 1985–86, the view now is that this was a name for the entire region, largely dismantled when the Danish Great Army took control over eastern Mercia in 874 and destroyed the church. The Danes also refortified Derventio's 25-foot-high Roman walls as a local strongpoint, rather underlining the ephemeral nature of the settlement around the church, despite its strategic position on a ridge flanked by two north-flowing watercourses – the Derwent and the Markeaton Brook. It was these Danes who probably mutated the Roman name into 'Derby' by adding the Norse suffix '-by' (meaning 'place') to the first element of the old name. The Victorian etymological construct that Derby was a new, entirely Norse, name meaning 'place of the deer' (no doubt influenced by Derby's late medieval municipal emblem of a buck lodged within park pales) no longer holds credence.

It was not until Aethelflaeda, Queen of Mercia, threw the Danes out of the area, including a successful siege of Derventio, in 917 that the foundation of the Derby we know today was able to come about. The initiative was taken in around 924. After the death of Aethelflaeda, Saxon England was united under the dynasty of Wessex and the person of the late Lady's brother, Edward the Elder. He died in 924 after having to put down a revolt by the Mercians, but his son Aethelstan established a network of fortified burhs, of which one was on the ridge to the west of the Derwent and included the damaged (but repaired) church of St Alkmund. It included a new minster church (All Saint's, Derby Cathedral since 1927), which was combined with St Alkmund's as a single monastic college, a mint, and a town ditch, connecting the Derwent with the Markeaton Brook running east-west north of St Alkmund's.

The establishment of the mint represents the first strictly industrial process since the demise of Roman industry in the early fifth century, and the names of the moneyers, as displayed on the reverses of the silver pennies they produced, demonstrate most emphatically the approximate 50-50 ethnic divide between Anglian and Norse among the élite of the new burh of Derby.

In around 1100, Derby's marketplace was laid out and from then on Derby flourished as a market and county town, its industries barely perceptible amid the growth of fashionable town houses and fine public buildings. By Georgian times, when it became one of the foci of the Industrial Revolution, it was much praised for its appearance and the vitality of its social life.

This, then, is the context for the real flowering, for good or ill, of Derby at Work.

PRE-INDUSTRIAL BEGINNINGS

n Roman times, a civil settlement (*vicus*) undoubtedly grew up around the defences of the Derventio fort. Indeed, a probable baker's shop was uncovered at the side of the road going north in excavations in 1926: the first known Derby tradesman, although the first named local citizens also appear in a trading context of the second century, 'PRI[VATUS] and SENILIS', both stamped on the base of Derbyshire ware pots made here on an industrial settlement east of Derventio. Activities here included the manufacture of these distinctive coarse wares, the fabric known from its goose pimple-like surface, the smelting of metals,

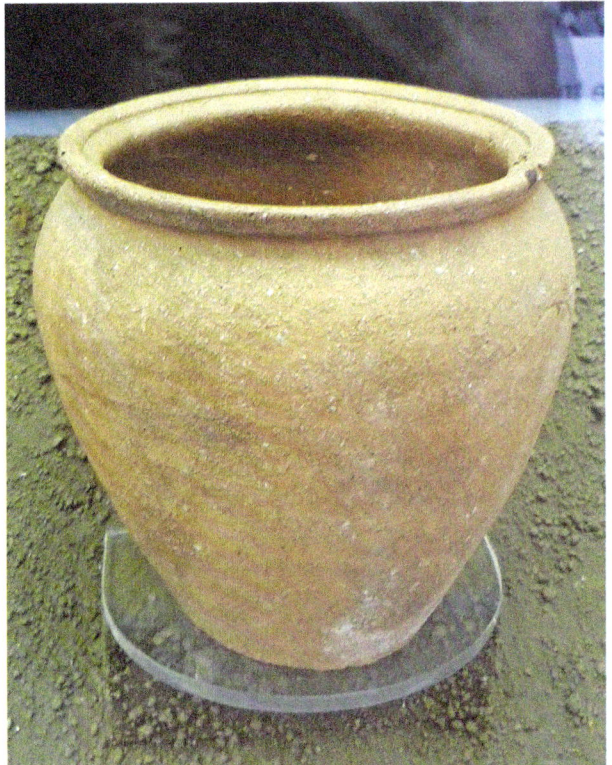

Derbyshire ware pots excavated from a kiln at Derventio, 1968. (Author)

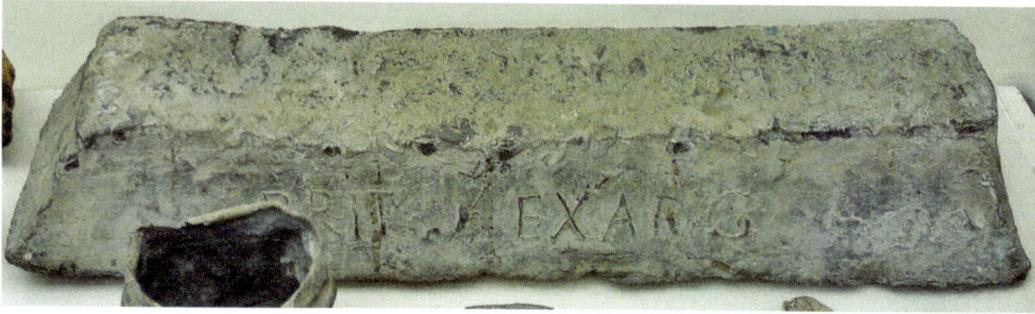

Roman lead pig from Little Chester in Derby Museum. (Author)

mainly lead, to make ingots ('pigs') for ease of shipment south by water, and other trades like tanning, essential to the maintenance of soldiery. Although the pottery making appears to have diminished during the later second century, the smelting continued, the settlement being quite probably an important trans-shipment point for the movement of lead from the Peak, mined under Imperial control.

Several Roman roads, including the north-east to south-west Rykneild Street crossed here, so trade undoubtedly burgeoned accordingly, over and above those transactions that solely resulted from the needs of the army. A Roman coal heap found elsewhere at Little Chester suggests that this fuel was imported from local sources, drift-mined not only for heating hypocausts but the pottery kilns and smelters too. The lead came from Wirksworth, 12 miles to the north-west, probably to be identified with the Lutudarum named on local Roman lead pigs.

After the early fifth century, industrial scale pottery making went into eclipse, but it would seem that in the Dark Ages, when upland Derbyshire was hotly contested between Mercia, King Cadwallon of Gwynedd and the Northumbrians, lead was still at a premium. By 714, Lutudarum/Wirksworth belonged to the Abbey of Repton (founded c. 650), when Abbess Eadburga sent St Guthlac at Croyland Abbey a lead coffin and, in 835, Kenwara, a later abbess, granted Wercesvorde (Wirksworth) to one Humbertus, for a rent of £15 worth of lead to be paid to Archbishop Ceolnoth to reroof Christ Church at Canterbury. Where all this lead was being smelted and reduced to transportable pigs is not, however, clear, but Derby's role in this may well have survived.

King Athelstan's new burh, the nucleus of Derby as we know it, was laid out in a grid pattern, the streets being lined with burgage plots set at right angles. These were tenanted for rent and occasional service by traders, all of whom became personally free thereby. Indeed, it is to this status by right of tenure in the borough to which we must look for the origin of the borough 'freeman', conferring considerable benefits, like the right to trade and take apprentices under successive royal charters.

One of the chief purposes of a Saxon burh was trade (after a measure of defence) and the lifeblood of the Saxon trade was coin. Offa of Mercia (reigned 757–96) introduced the penny, based on the Roman *denarius*, hence the abbreviation 'd'. It swiftly became the universal English (and later also Norse) medium of exchange. Each burh had a mint, to which dies were distributed from either York or London for the striking of the royal coinage, done by local mint masters who additionally placed their names and that of the burh on the coins. They were men of considerable consequence. A mint was established in the new burh of Derby under Athelstan (924–39) and its mint masters constitute the earliest body of named Derby citizens known to us, and they are a valuable record of a proto-industrial coterie.

When the Domesday Book was compiled in 1086, the number of burgesses had dropped from 243 in 1066 to 140, with 103 empty dwellings; there were four fewer mills (ten). Furthermore, Derby's first surviving charter of around 1155 accords mercantile pre-eminence to Nottingham, although the coin issues between 925 and 1154 (when minting ceased) suggest that Derby was previously much in the ascendant in this respect. Indeed, the last of the Derby mint-masters, Walkelin de Derby, was a member of an extensive ruling dynasty that dominated the borough in the twelfth century. Derby streets also help us to understand some of the trades and crafts of the early town: Iron Gate (1318, smiths); Sadler Gate (*c.* 1248, saddlers); Leather Lane (leatherworking/glove making), The Shambles (butchery), Bold Lane (bolt/arrow making) and Walker Lane (*c.* 1263, fulling) all occur before the fifteenth century and the Norse suffix '-gate' to some streets attests to the lasting linguistic influence of a substantial Danish minority.

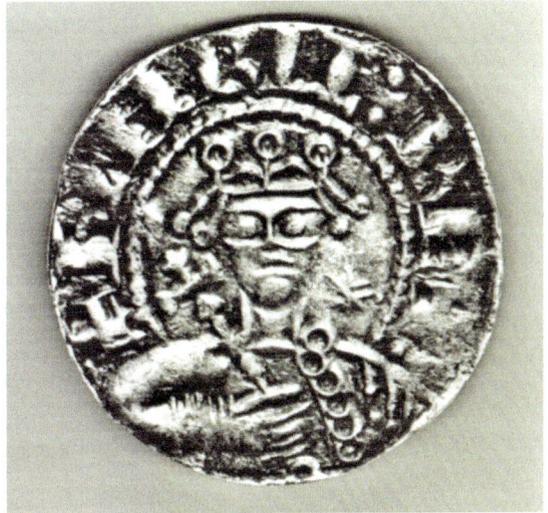

Derby mint – a silver 1*d* of Henry I struck by Brun. (Derby Museums Trust: DMT)

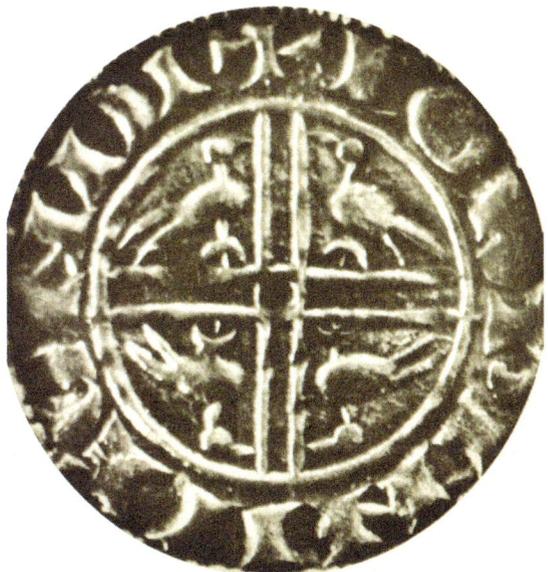

Derby mint – a silver 1*d* struck by Walkelin. (DMT)

Iron Gate, looking south, 1855. (DMT)

Walker Lane during slum clearance, 1947. (DMT)

Sadler Gate, September 2015. (Author)

Pottery making, however, revived in the Derby area quite soon after the Conquest. By far the commonest medieval archaeological finds in the city are green glazed (and occasionally unglazed) pottery sherds of around 1250–1350, mainly parts of pitchers with narrowish long necks and decorated handles. These appear to have been made at Burley Hill immediately to the north of the city boundary, but within the medieval parish of St Alkmund. Here a kiln was uncovered in 1862, four others being excavated in 1957. Pots frequently bear horseshoes, the pre-heraldic insignia of the de Ferrers Earls of Derby. Late in Henry III's reign, the significantly named Alan the Potter held the site of the pottery. Other workmen are known from their names: several generations of a family called goldsmith (*aurifaber* in the old charters) attest to goldsmithing in the burh.

In the late-fourteenth century, several grand trading families made vast fortunes in Derby. John Stokes, a Derby MP from 1386 and a descendant of a Derby baker, made a huge fortune in the wool trade as did the Shores (Jane Shore was a mistress of Edward IV) and the Thackers, the latter subsequently wealthy enough to buy the dissolved Repton Priory. With the wool trade came dyeing, which was an important medieval business in Derby, despite it having originally been reserved to Nottingham in the 1155 charter - a slight reversed in 1199. Robert Liversage was one of the wealthiest, leaving at his death most of his property in trust for the housing of thirteen poor people of St Peter's parish. The charity he founded is today the largest landowner in the City Centre.

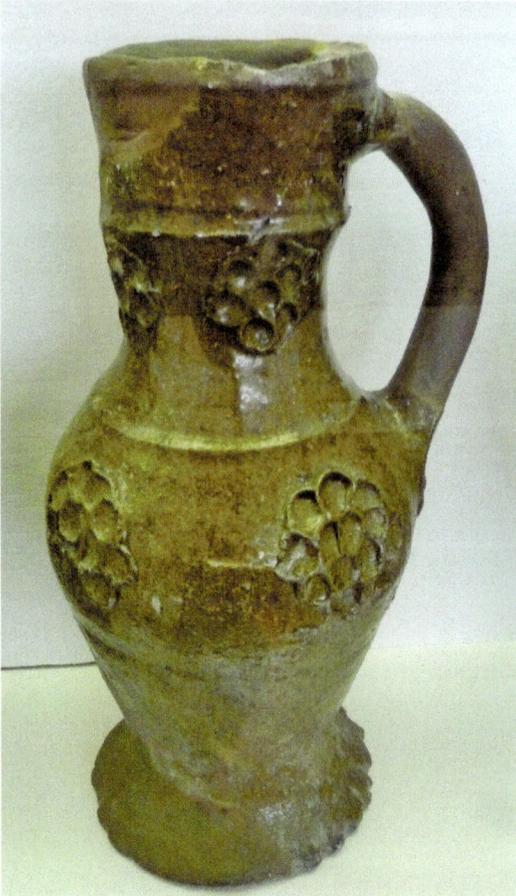

Burley Hill pottery flask (*c.* 1200) in Derby Museum. (Author)

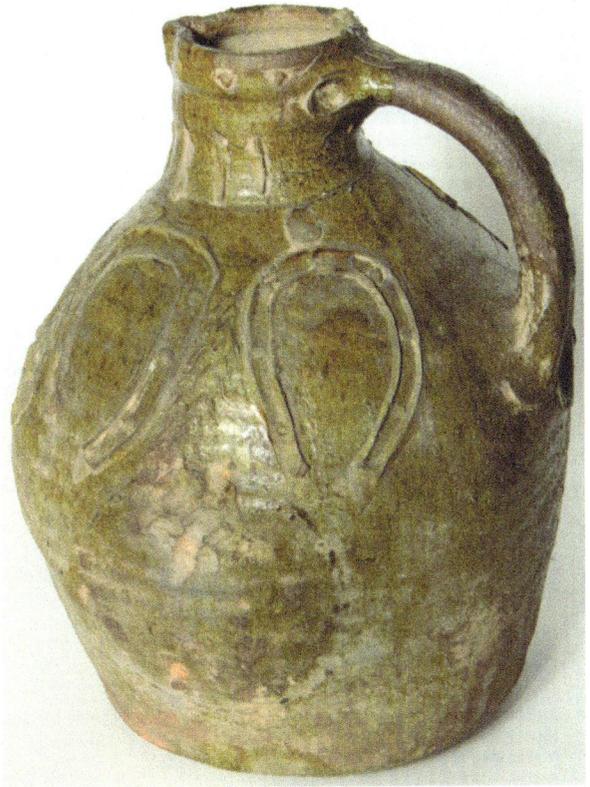

Right: Burley Hill jug with de Ferrers horseshoes, *c.* 1240. (Hansons)

Below: Liversage Hospital, London Road, August 2011. (Author)

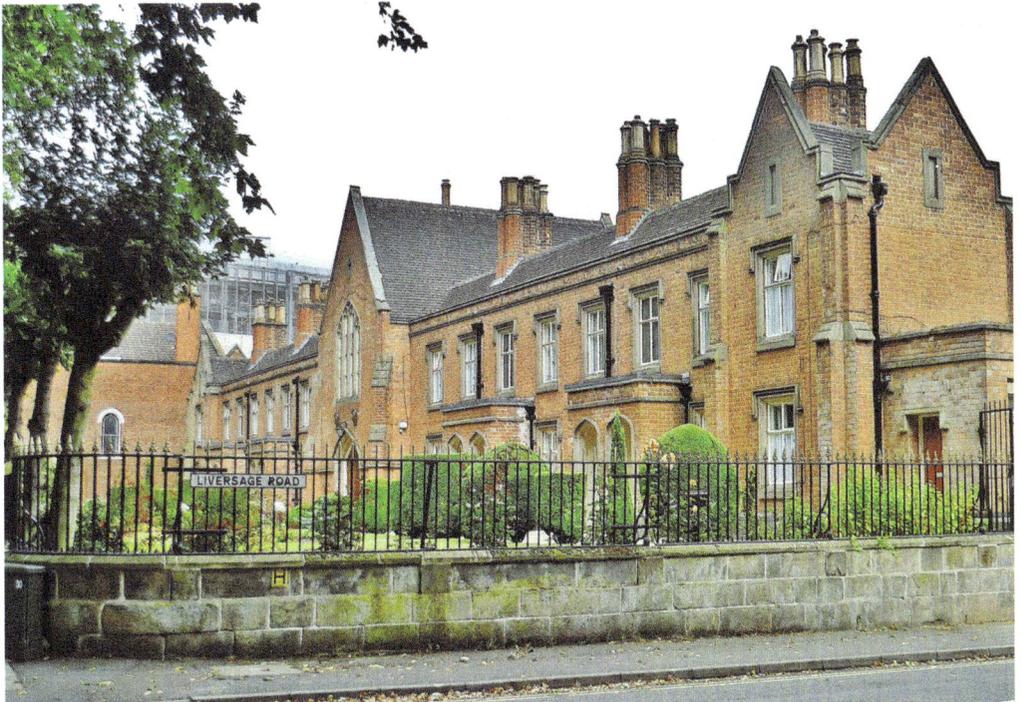

A sample of late Tudor Derby prices can be found in the commonplace book of Roger Columbell of Darley (Dale) Hall, who died in 1605:

Stuff bought at Derby against my daughter Troth's weddinge.
God preserve her. Sept. 1587:

	s	d
1 oz of sylke	12	
3 dozen buttons	9	
1 yd of fustian	8	
1 oz of fringe lace	13	4
ii payre of Jersey hoos [hose]		
4 elnes [ells] of changeable		
taffata for ye gowne	54	4
for lace sylke and fringe of		
ye same gowne	15	6
Hoose [hose] ii payre	2	0
Fringed lace for my wyves		
petticoate	2	8
Lace and fringe for the		
kirtle	2	4

This comes to £4 12s 7d (£4.63) – weddings were never cheap!

Nor should it be forgotten that from an early date, Derby was renowned throughout the kingdom for the quality of its beer, long before Burton-upon-Trent. As early as 1662 the town was noted for this, Thomas Fuller having noted: 'Never was the wine of Falernum better known to the Romans than the Canary (Ale) of Derby to the English'. Indeed William Woolley in 1713 considered malting Derby's principal trade. Thomas Cox, writing in 1730, said of it:

'This drink is made here in such perfection, that wine must be very good to deserve a preference', adding a wonderfully apposite piece of Latin doggerel on the subject, which, in translation, reads:

> Of this strange drink, so like the Stygian Lake,
> Men call it Ale, I know not what to make.
> They drink it thick and piss it wondrous thin:
> What store of dregs must needs remain within?

Not only Fuller but previously William Camden also recorded Derby as an important centre for brewing. In the first decade of the seventeenth century, Derby Nappy Ale and Canary Ale were celebrated long before Burton-upon-Trent later gained pre-eminence. Indeed, Derby's brewing industry survived vigorously until the middle of the twentieth century.

Why Derby Ale should have been called Canary is quite obscure, unless it was the colour. The water meadows east of the Derwent, now crossed by Derwent Street, are called Canary Island, but no obvious connection between the two presents itself. Brewing continued in Derby until the last established firm, Offiler & Co. was sold to Bass Charrington and closed down on 30 September 1966, although from the 1980s several micro and craft breweries have flourished.

The restoration period in Derby, as elsewhere, is marked by the physical survival of half-penny and farthing unofficial copper trade tokens issued from 1657 until 1671, because of a lack of official base metal coinage. Analysis of the forty-eight different types (issued by

ALTON & Co., Ltd.,

BREWERS,

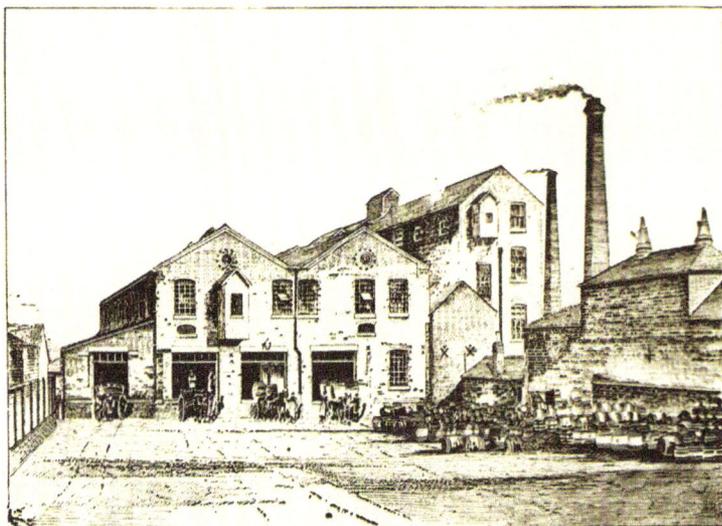

𝔚ine and 𝔖pirit 𝔐erchants.

WARDWICK BREWERY,

DERBY.

For descriptive Notice see page 47.

Wardwick,
Alton's Brewery
advertisement,
1891. (Author)

thirty-seven different tradesmen) gives us a fascinating cross section of local trades at a period when Derby's fortunes had begun to rise. Mercers were the most common issuers (five), followed by vintners and apothecaries (three), then carriers, bakers, inn holders, shoemakers and grocers (two each) and one each of coffee house proprietor, bookseller, felt maker, dyer, tallow chandler, wool packer, saddler and smoking pipe-maker. Many of these issuers – certainly all those who practiced as either mercers, apothecaries, grocers, ironmongers, upholsterers or milliners – also belonged, from its foundation on 28 July 1675, to the Derby Company of Mercers, which met at the surviving Old Dolphin Inn, Queen Street, in the Restoration period. There was also a Derby Drapers' and Tailors' Company extant by 1622, yet they and other similar ones combined control of traders with a measure of self-regulation and welfare. Thus, although founded under Act of Parliament dated as far back as 1436, they also looked forward to the Friendly Society as well as to bodies such as the local Chamber of Trade.

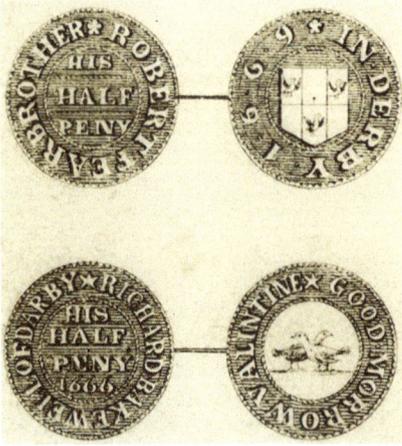

Derby tokens: Robert Fearbrother, tallow chandler; Richard Bakewell, carrier. (Author)

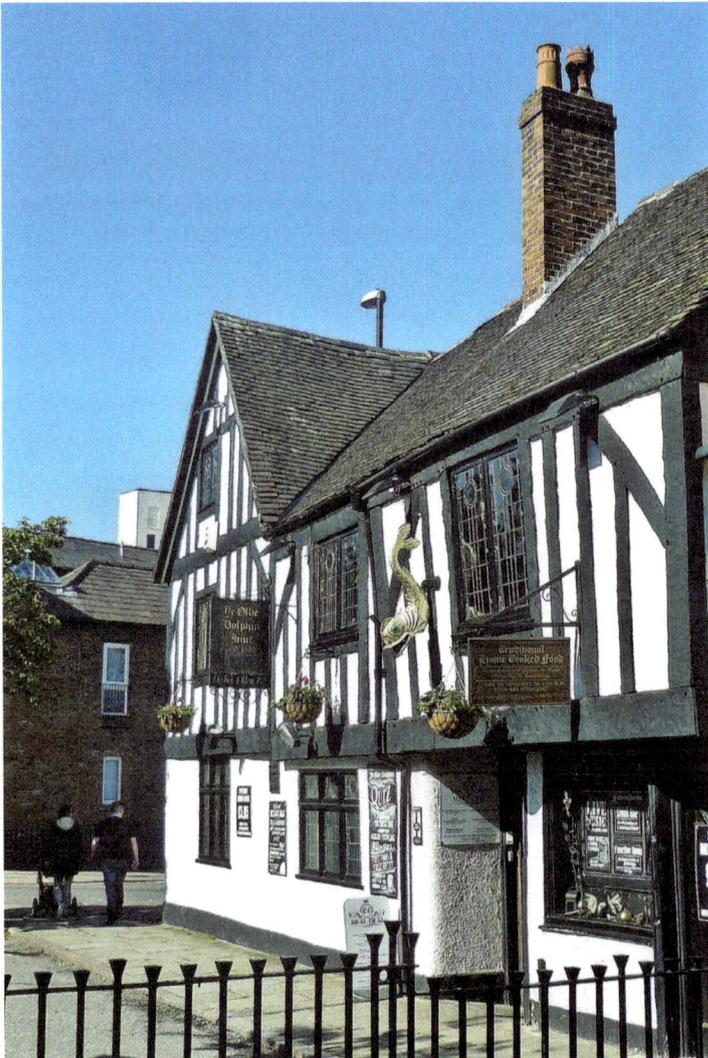

Old Dolphin Inn, Queen Street, May 2015. (Author)

INDUSTRIAL AWAKENING

The Industrial Revolution came to Derby earlier than most, although its most important manifestations were more cerebral than practical, with two members of the famous Enlightenment coterie, the Lunar Society, resident in Derby. Indeed, it was a series of mechanically gifted men with a talent for working with water that really drove the Industrial Revolution in Derby.

The first person who manifests himself in this saga was George Sorocold. He was of Lancastrian descent, of a family of gentle standing. James, his father, was steward of the Lancashire estates of the main Derbyshire grandees, the Cavendish Earls of Devonshire. George was born in his native county but moved to Derby, marrying the daughter of a rich

East Prospect of Derby, 1693. Lithograph of an original at Renishaw Hall. Sorocold's water engine's wheels are visible just to the right of the larger island. (Author)

Derby alderman in 1684. His career developed as a millwright and hydraulic engineer, but like so many of the scientific figures who are linked with Derby, his interests and attainments became increasingly diverse. In 1687, he rehung the ten bells of All Saints' Church, one of which still bears his name. He later also installed a carillon to play seven tunes on them.

Also, in 1687, he designed and built a water supply for the Cheshire town of Macclesfield and developed a sophisticated device for raising and distributing water, which he installed as part of a similar scheme at Derby in 1691. This brought water from the River Derwent to a storage tank virtually opposite the home of England's first Astronomer Royal, John Flamsteed FRS, whose acquaintance he duly made. The water flowed from thence through elm pipes to a number of public outlets, called conduits, which he also designed. In its flow, the water turned an engine that could be adapted either to bore out more elm pipes or to grind flints, thus virtually financing itself.

This system, with variations, Sorocold later established at seventeen other towns and cities, and he developed hydraulic works of a similar nature for gentlemen's parks including at Melbourne for Thomas Coke and at Calke for Sir John Harpur Bt. His 'water-lifting engine' only finally became redundant after Whitehurst introduced his hydraulic ram of which more later. While working with London and Wise on the gardens at Melbourne, Sorocold met Robert Bakewell, England's greatest native-born ironsmith, a former pupil of Jean Tijou, who was then making the unique and beautiful iron arbour there.

Sorocold also built the docks at Rotherhithe and designed and built the first dock at Liverpool with the Derby architect Henry Huss (d. 1716). He also used his hydraulic talents in the lead and coal mines of Derbyshire and elsewhere — even as far away as Wales and Scotland — to drain the deeper shafts, usually by way of a tunnel descending to the nearest watercourse (in Derbyshire called a sough). He was also heavily involved in lead mining and the engineering associated with this financially risky trade as a specialist builder of soughs.

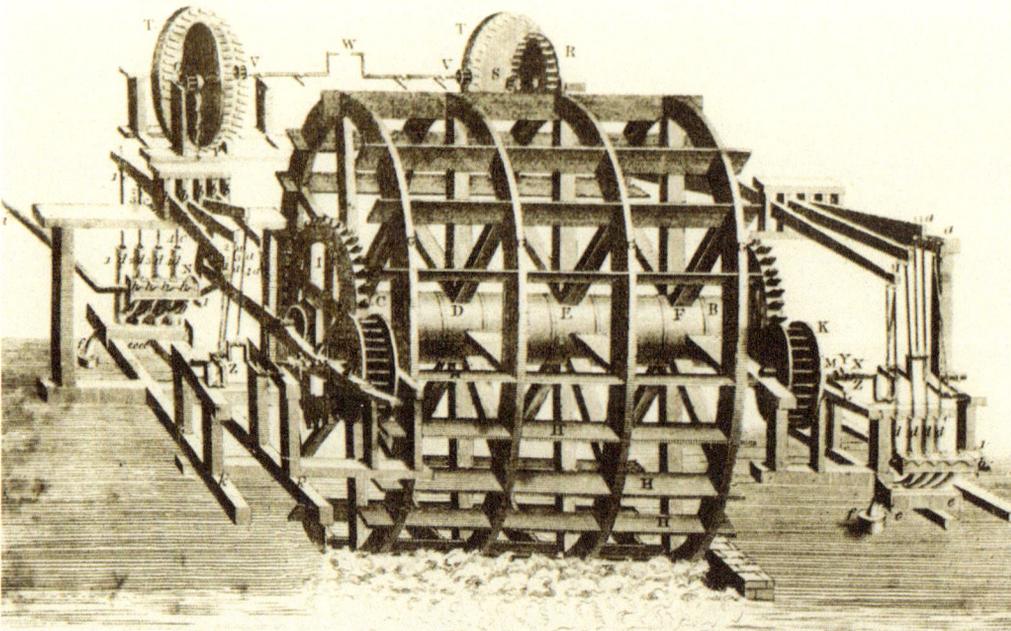

Sorocold's water engine. (Author)

Melbourne Hall, Bakewell's arbour.
(Author)

Revd John Flamsteed, FRS, first Astronomer
Royal. (Author)

He was involved with the Cromford Sough in 1705 and a decade earlier Flamsteed, who had inherited extensive mining interests from his father, employed Sorocold to un-water some of his mines near Bakewell, thus confirming their acquaintanceship.

More important still, Sorocold worked closely with Thomas Savery — with Newcomen, the pioneer of atmospheric engines or 'fire-engines' — who wrote glowingly of his abilities. Indeed, that association may have led to the first installation of an atmospheric engine in a Derbyshire lead mine, than at the Yatestoop mine in Birchover in 1716. Savery may have used atmospheric engines even earlier in coal mines, which links back to Flamsteed, for Savery is believed to have installed one at a coal mine in the Denby area for him a decade before.

Yet Sorocold's two greatest achievements were yet to come. In 1721, after almost two decades of wrangling to obtain an Act of Parliament, the Derwent Navigation was opened from Derby to the River Trent, largely utilizing the River Derwent, suitably canalized. For this project, Sorocold drew a very fine map showing the proposed works, echoing Flamsteed, who had surveyed (but not published) a map of Derby in 1673. Once completed, this proved to be a considerable boost to Derby's trade and made possible the foundation, not long afterwards, of an important copper rolling and slitting mill on The Holmes, an island in the Derwent at Derby just south of the town.

The completion of the Derwent Navigation occurred in the same year as the completion of the second of these achievements, the construction and engineering of the celebrated Derby Silk Mill 1718–21, arguably Britain's first factory, and the wonder of its age. The promoter, Sir Thomas Lombe, had encouraged his much younger half-brother John to acquire the technology for the machinery by stealth from Italy, sending the drawings back to Derby, where Thomas, with Sorocold's help, fabricated them in the Moot Hall. We now know, of course, that this early case of industrial espionage would have been superfluous had the Lombes realised

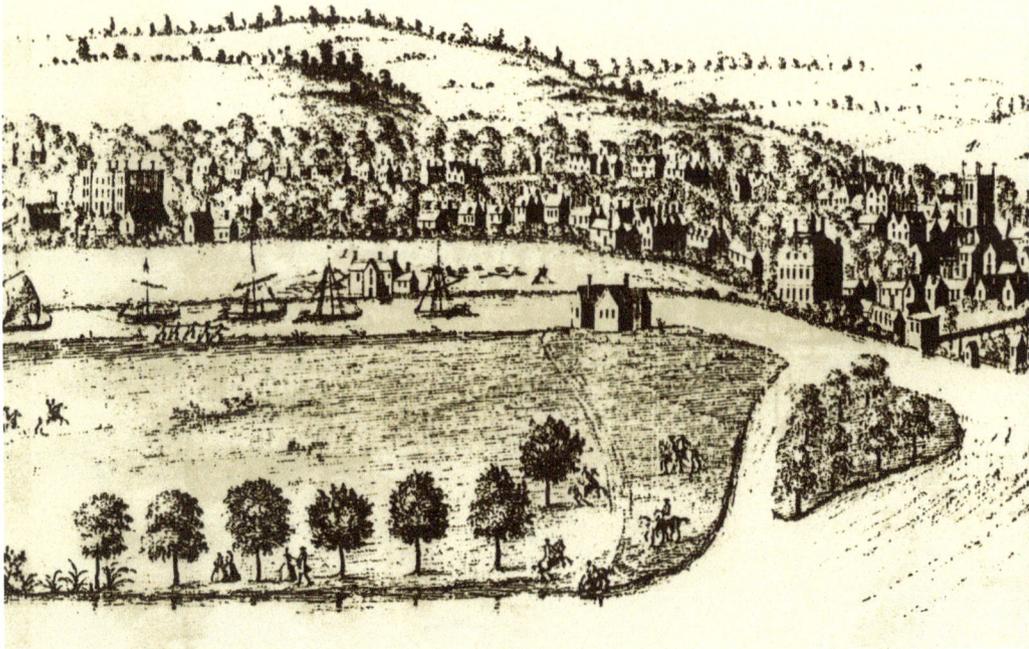

Derwent Navigation and The Holmes, by Buck, 1728. (Author)

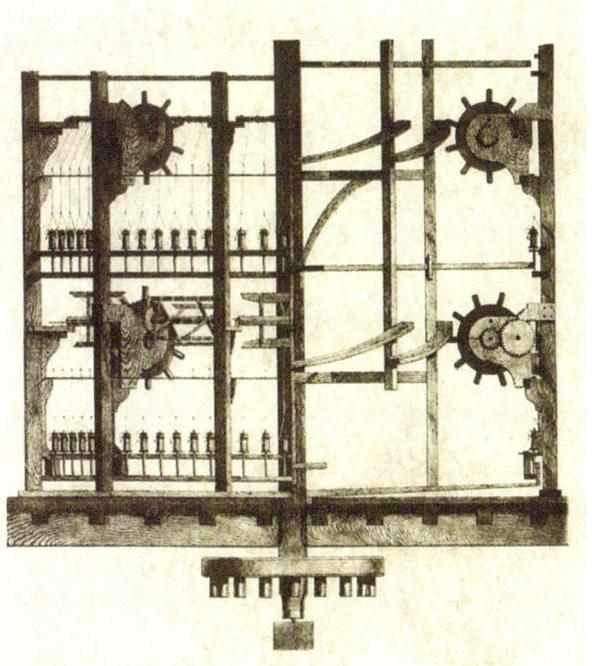

A silk-winding machine. (DMT)

that complete details of the relevant machines, published by Vittorio Zonca in 1607, were available in the Bodleian Library.

At the same time Thomas Steers designed the mill and Sorocold the engineering required to run the machinery from a single power source — the specially constructed mill stream — fed by the Derwent, and into which, Defoe records, its designer spectacularly fell when demonstrating it after completion. The main mill (called the Italian Works) was five storeys high with a single work floor on each and was 110 feet long and 39 feet wide. Immediately south of it was the doubling shop, in which the spun and thrown silk was doubled to endow it with strength; this was unpowered and was 140 feet long and only 19 feet wide and three storeys tall. Between the two was installed, around 1731, an atmospheric engine, then called a 'fire engine', which '…conveys warm air to every individual part … the house which contains this engine is of vast bulk, and five or six stories high'.

This, contrived by Sorocold's friend Thomas Savery, was designed to circulate warm air throughout the building to ensure the silk threads did not snap, as they were prone to do in low temperatures. The historian William Hutton, who worked there as a child from 1740–47 said of it, 'To this curious but wretched place I was bound apprentice for seven years … It is therefore no wonder if I am perfectly acquainted with every movement of that superb work.'

The atmospheric engine installed by Sorocold and Savery in this pioneering development leads forward to Derby clockmaker John Whitehurst FRS, a co-founder of the celebrated Lunar Society and one of the lynchpins in the burgeoning of the Industrial Revolution. In 1776 Whitehurst was closely involved in the evolution of Boulton and Watt's steam engine — or 'fire engine' as Boulton also termed it — suggesting to them in a letter written from Derby that year the reuse of the exhaust steam to produce the double-acting engine that the pair finally and so momentously evolved. And, like Sorocold, who died in 1738, a couple of years after Whitehurst had taken up residence in Derby (certainly ensuring their acquaintanceship),

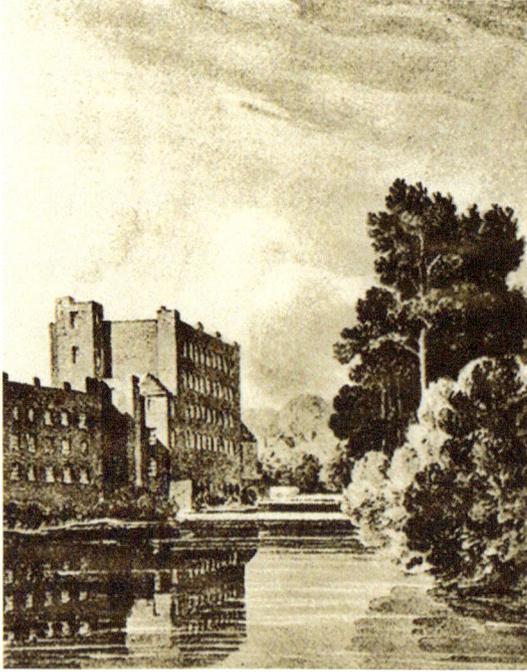

Left: The Derby Silk Mill from the south-east by George Robertson, *c.* 1790. (DMT)

Below: The silk mill and surroundings, *c.* 1730. (DMT)

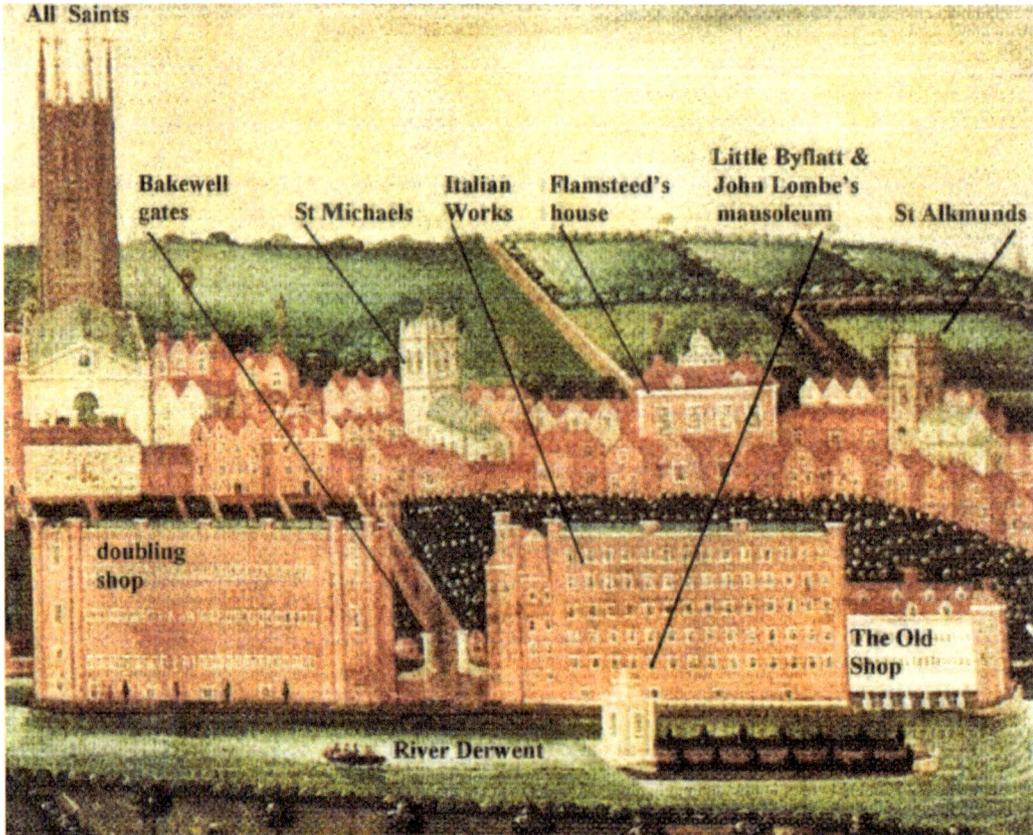

All Saints

Bakewell gates

St Michaels

Italian Works

Flamsteed's house

Little Byflatt & John Lombe's mausoleum

St Alkmunds

doubling shop

The Old Shop

River Derwent

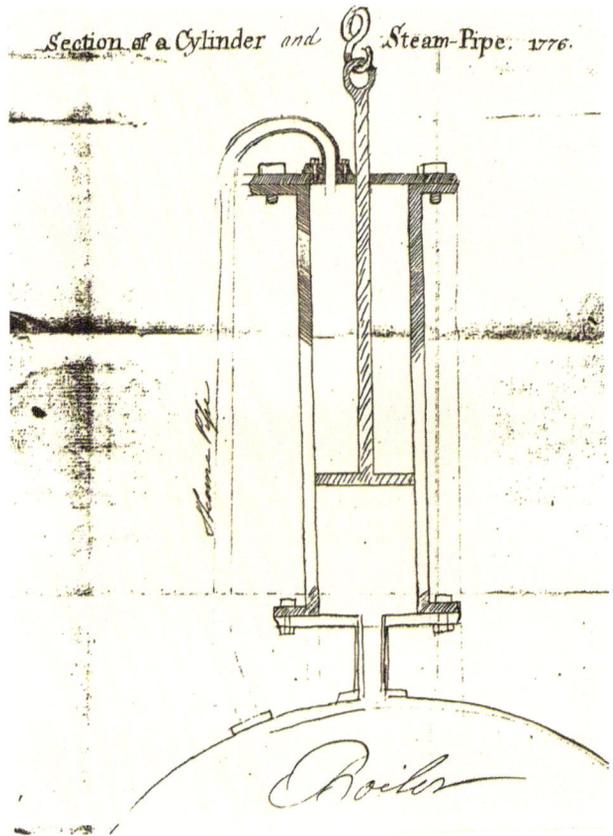

Section of a Cylinder and Steam-Pipe. 1776.

Boiler

Whitehurst's modification to
Boulton's steam engine, 1776.
(Birmingham Archives)

Whitehurst turned out to have a great flair for hydraulics, and it may be that the former inspired him, or even taught him what he knew.

Sir Thomas Lombe's patent expired in 1732, after which his method spread elsewhere, notably to Congleton and Macclesfield in Cheshire, not to mention the twelve other silk throwing mills that had sprung up in Derby by the early nineteenth century; even James Wyatt's huge Ordnance Depot, erected in the heat of the Napoleonic Wars, was adapted into one.

The silk mill flourished under various owners and lessees until 1826 when it caught fire. The conflagration seems to have damaged the two upper storeys, but failed to prevent it from working after being patched up, for it did not undergo serious alterations until around a decade later, when it acquired its broached arcaded bell tower and hipped roof. In 1865, as a result of the tariff agreement with the French, the operator became insolvent and it became a laundry and later a factory for making medical products, burning down again in 1910 (two decades after the total collapse of the doubling shop), after which it was rebuilt as a three-storey building, becoming a museum in 1974.

The silk mill presaged the arrival of industry in the English Midlands and specifically those associated with the luxury end of the market. Until 1952, Derby was a county town serving a hinterland full of mineral-rich gentry estates, the owners of which mostly kept town houses in Derby. Indeed it was their conspicuous consumption that enriched one particular mercer, Abraham Crompton, who put his profits to good use by establishing a bank in 1685. The Regency historian Stephen Glover wrote: 'Through [his] hands the principal trade of the Borough seems to have been conducted … the first regular banker of the place.'

Above: Normanton, the former ordnance depot, as silk mill letterhead of the 1840s. (Author)

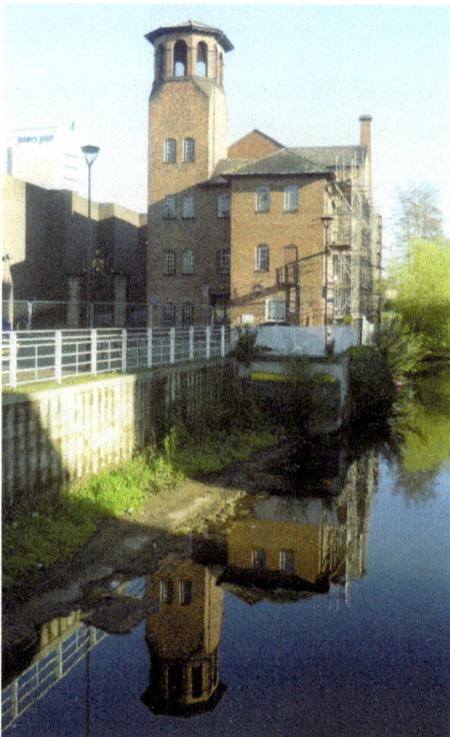

Left: The Derby Silk Mill, April 2017. (Author)

The Derwent and the Silk Mill, 1855 – calotype photograph by Richard Keene. (DMT)

Although Crompton's enterprise was imitated at Derby (with varying degrees of success) in the century following, his efforts were richly rewarded and, as Crompton & Evans' Union Bank (1877), it endured until 1914 and was absorbed by the Westminster (now NatWest) Bank 1918.

With such a vehicle to underwrite enterprise, there came also a harbinger of heavy industry. Thomas Chambers (1660–1726) was the first super-rich Derby resident, who made a vast fortune dealing in metals, most prominently copper (from the Staffordshire Peak), cakes of which appear on his coat of arms along with a miner in a mine as his crest, both prominently displayed on his monument in Derby Cathedral designed by Louis-François Roubiliac and adorned with ironwork by the incomparable Bakewell.

Chambers' operations were taken over by lead merchant Thomas Evans, who in 1734 founded an ironwork on an island in the Derwent called The Holmes, adding a copper-rolling mill (to meet the needs of the Navy's ships' bottoms) in 1737. Its very presence was testimony to the efficacy of Sorocold's Derwent Navigation. Evans's son-in-law (also Thomas Evans) used the profits from this enterprise to found another local bank (which amalgamated in the later nineteenth century with Crompton's) and in 1782 he added a vast cotton mill at Darley Abbey a mile to the north of Derby to his interests. The elder Evans's 'rolling, battering and slitting mills' survived under the ownership of the Bingham family until the 1830s.

Yet, the tendency to look to manufacture goods aimed at what today are called 'high-end' consumers continued in 1750 with the establishment of the Derby Porcelain factory. Again, waterborne transport of fragile products like china was essential to prevent wastage, and the Derwent Navigation, extended to a creek by St Mary's Bridge on Nottingham Road where the factory was built, again proved a crucial element.

The factory had its beginnings a year or two before when André Planché established a small atelier producing fine porcelain figurines in a former clay pipe kiln in Bold Lane. The expertise of Cannock-born William Duesbury and the finance of banker John Heath led to operations moving to a new works on Nottingham Road, and soon the factory was going from strength to strength, albeit that poor Planché was eased out by the canny Duesbury. Not long after, the Chelsea factory was absorbed and a London showroom established. Distinguished visitors

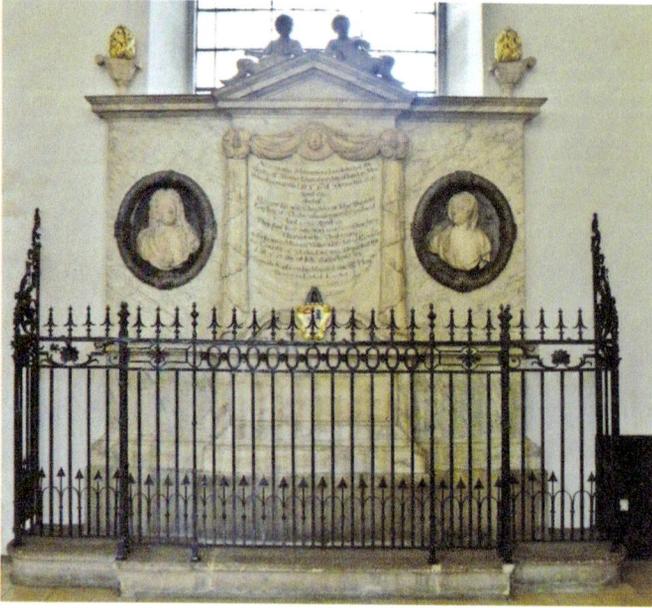

Monument in the cathedral to Thomas Chambers. (Author)

Arms of Thomas Chambers with copper billets and miner. (Author)

Right: Thomas Evans portrait, probably by Thomas Barber, c. 1800. (Bamfords)

Below: The Derby china factory on a Michael Keen coffee can of c. 1800. (Bamfords)

Left: Silhouette by Edward Foster of William Duesbury Snr, *c*. 1770. (Author)

Below: Cockpit Hill pottery – American colonies propaganda piece. (Smithsonian Institution)

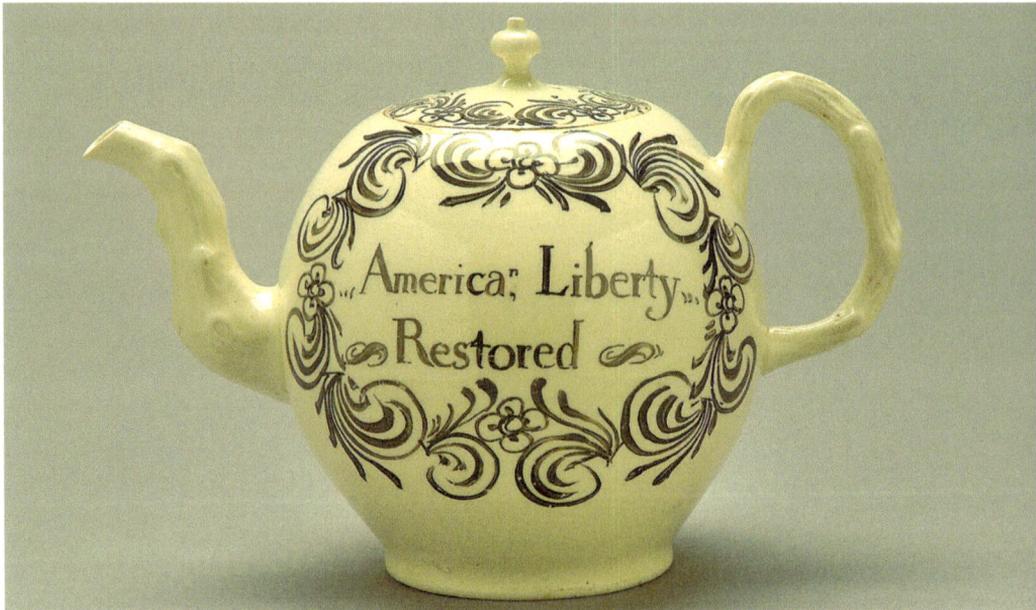

included Dr Johnson (1777), who, according to Boswell, '…justly observed that it was too dear, for that he could have vessels of silver of the same size as cheap as what were here made of porcelain.'

Almost simultaneously with the founding of the china factory, a trio of entrepreneurs also founded a pottery on Cockpit Hill across the river, making fine domestic earthenware products, also backed by John Heath.

INDUSTRIAL REVOLUTION

The beginning of the Industrial Revolution in Derby lies with John Whitehurst FRS. Born the son of a clockmaker in Congleton, Cheshire, in 1713, he served his apprenticeship with his father before setting out to improve himself, visiting Dublin and London before deciding to leave it to his brothers to succeed his father and settling in Derby. In Derby, Whitehurst could see opportunity: the wealthy members of the landed upper classes with houses in the town, the silk mill and the rolling mills, and the flourishing markets all suggested that here was a place where he could flourish.

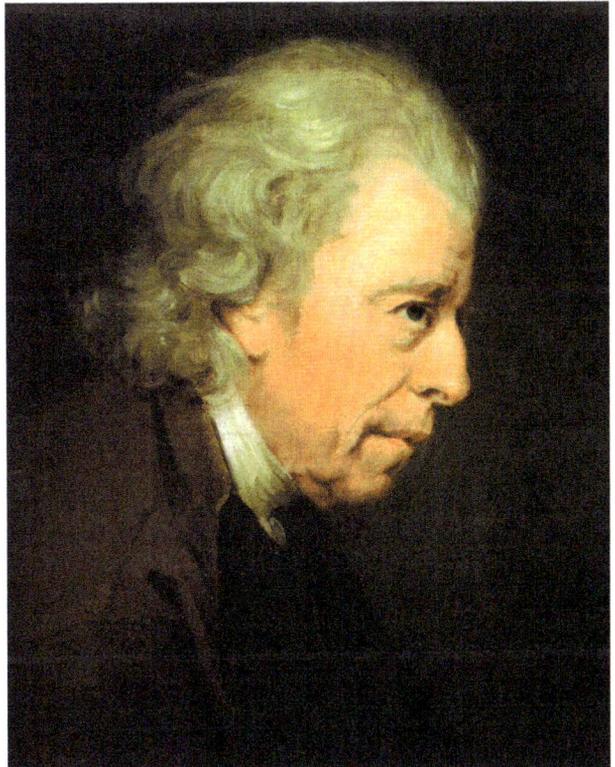

John Whitehurst, detail of
Joseph Wright's portrait, 1780.
(Smith of Derby Ltd)

1731 Guildhall (centre right) pictured by George Pickering, 1828. (DMT)

Derby's royal charter allowed only freemen, sons of freemen, or their passed apprentices to trade on their own account, which was an advantage Whitehurst did not have, so, on his arrival in 1736, he was obliged to trade from a stall in the market and sell dials and movements, probably supplied by his father in Congleton. Here he seems to have made the acquaintance of Sorocold and, at the suggestion of James Woolley of Codnor, made a turret clock for Derby's new Guildhall in Market Place, for which he was rewarded with a grant of freemanship in 1737.

Clockmaking is usually dismissed as a craft trade rather than an industry, but here Whitehurst broke new ground. He ensured his clocks were made of the best materials, using the same piece of brass for all the moving parts of a single clock (ensuring uniformity of expansion and contraction to improve accuracy) and machining the movements to very high tolerances to ensure the best timekeeping and precision. He also standardised parts wherever he could, and simplified his clocks, introducing the plain silvered round brass dial to cut the cost of manufacture, ensuring better value for the same money. To achieve this he set up a works behind his house in Iron Gate and employed his brother George to manage it. He never looked back.

This left him the freedom to do a great deal of what today we would call networking and by 1758 he was a friend of Matthew Boulton, just setting up as a manufacturer in Birmingham, and of the newly fledged and fashionable Lichfield GP, Erasmus Darwin. They met regularly, nurturing fertile ideas and inventions together. Whitehurst perfected a pyrometer for Boulton, and made him other instruments, including a barometer using a 0–60 scale of pressure devised by himself. By 1764 they had been joined by pottery manufacturer Josiah Wedgwood, two Scotsmen, glassmaker James Keir and engineer James Watt, along with two talented landed gentlemen, Thomas Day and the Irishman Richard Lovell Edgeworth. Later they were joined by chemical pioneer and Unitarian minister Joseph Priestley.

They met at each other's houses, usually in Birmingham, monthly on the Sunday evening of the full moon (to ensure safer travel) for supper, over which ideas would fly around with bewildering intensity. Priestley later called them the Lunar Society because of this, although as he was a minster, meetings were later transferred from Sundays to Mondays. Their coterie was the intellectual driving force and the crucible in which the Industrial Revolution was to evolve into a transformational supranational phenomenon and a tangible expression of the Enlightenment principles under which the group lived their lives. Encouraged by their mentor, the American diplomat, inventor and founding father Benjamin Franklin, they espoused freemasonry, anti-slavery, colonial self-expression and in due course the precepts underlying the French Revolution. They believed in the power of scientific progress to better mankind, and endeavoured to practice what they preached.

Right: Whitehurst round-dial long-case clock, *c.* 1770. (John Robey)

Below: Detail of angle barometer by Whitehurst with 0–60 scale. (D. Summers)

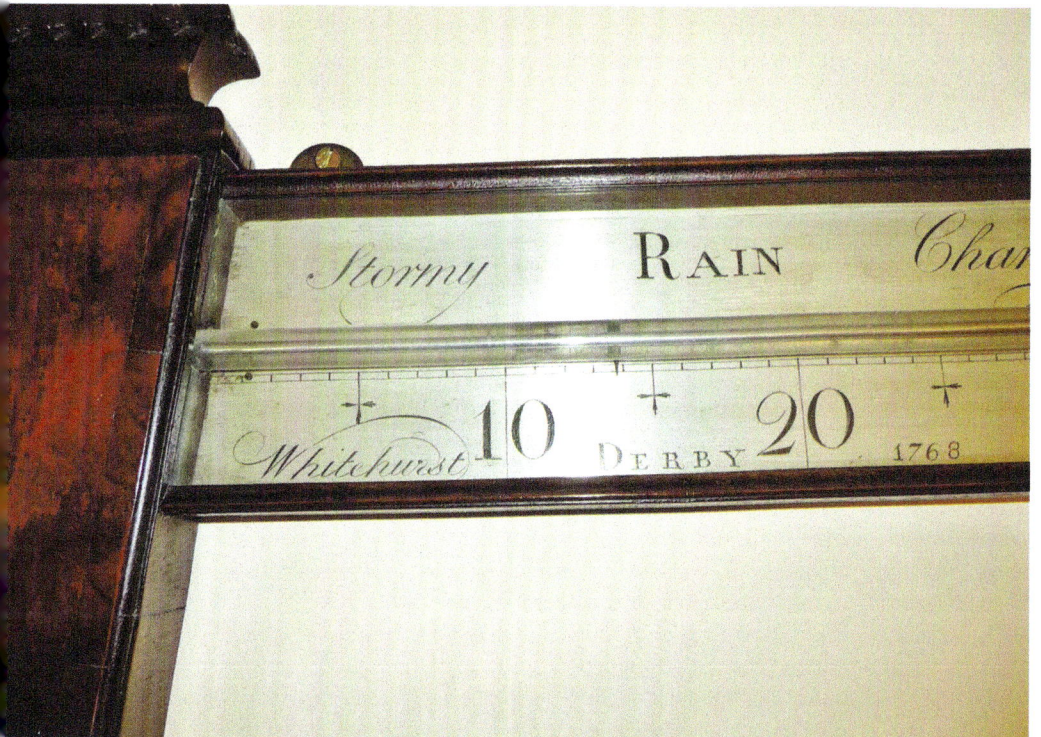

Whitehurst, who eventually moved to London in 1780 (where he had long been a stalwart of the capital's scientifically inclined coffee house societies), was replaced in Derby by Darwin, newly remarried to the widow of a local grandee. The zeitgeist of the age drew from both a bewildering array of innovations: Darwin invented the artesian well to provide water for his new house by the Derwent, to avoid having to drink its increasingly polluted waters, an advanced steering gear for carriages that transformed manoeuvring and kept a commonplace book teeming with other ideas, medical, natural and mechanical, by no means all of which were to see the light of day, not at least in his time. Whitehurst meanwhile showed himself capable of making almost any form of mechanical contrivance, not to mention improvements to kitchen ranges, flushing lavatories, heating systems and notably the hydraulic ram, originally commissioned by locally based landscaper William Emes to aid the workings of the cascades in gentlemen's parks. Like Darwin's artesian well, it was to transform farming both at home and later abroad; today both are key elements of watering Third World agriculture.

Whitehurst was also a pioneer geologist (aided by Darwin) writing a treatise on the origins of the earth in 1776 (but started before 1763) and republished in improved form in 1782. He codified the strata of rocks beneath the earth, which transformed mining from a hit-and-miss affair when it came to opening up new deposits into a much more precise business, enabling shafts to be sunk to reach deposits more or less precisely. He was also able to advise Duesbury at Derby and Wedgwood at Etruria (Stoke) on what minerals to add to their kilns to produce specific colours, not to mention making timers for them and machines to grind the colours.

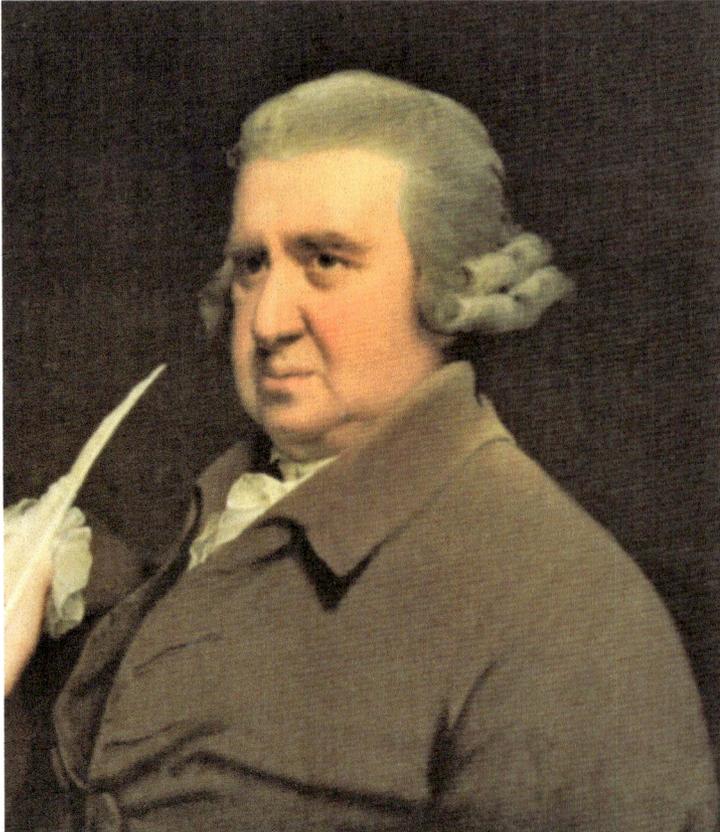

Erasmus Darwin, MD, FRS, after Joseph Wright. (DMT)

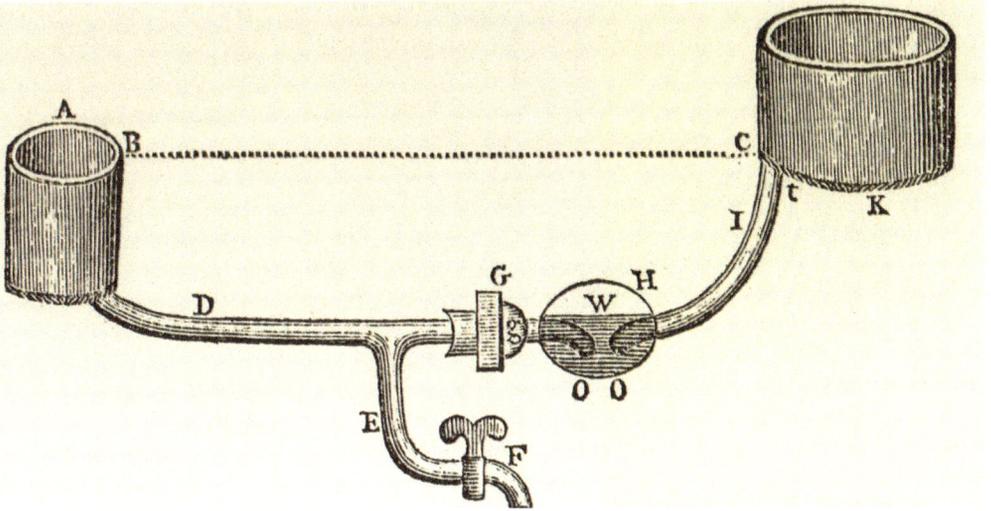

Above: Whitehurst's pioneering hydraulic ram, 1776. (Author)

Right: Dial of engine time clock by Whitehurst. (R. B. L. Wall)

It was against this background that a transformation came over Derby and its industries, with the Lunar Society members, especially Whitehurst, behind many developments. The geological emphasis of Whitehurst led to the introduction of spar turning to Derby by Richard Brown. His father, clerk to the parish of All Saints', had established a works in the 1730s housed in the Old Shop, the unused timber-framed predecessor of the silk mill, where water-driven saws and lathes of his own devising were used to cut and turn the polished minerals of Derbyshire: Chellaston alabaster, black marble from Ashford-in-the-Water, light-grey Hoptonwood and fluor spars from the Dark Peak. The majority of the work seems to have been in the creation of mural monuments for churches to commemorate the grandees of the town and county, but some architectural and ornamental work was undertaken too.

The younger Richard added real sculptural genius when he took the firm over in the 1760s and was fortunate in being related to the family that held the concession for mining that

Richard Brown's trade card, c. 1770. (Birmingham Archives)

Kedleston Hall, April 2013. (Author)

incomparable Derbyshire spar, Blue John. He supplied the 1st Lord Scarsdale with numerous exquisite ormolu mounted ornaments, as well as inlays for chimney pieces, to help embellish Kedleston, then being built under the direction of local architect Joseph Pickford to the designs of Robert Adam. Matthew Boulton saw them and immediately wished to enlist Whitehurst's aid to outdo Brown in making the finest Blue John ormolu mounted ornaments, which he tried (with mixed success) to sell to the crowned heads of Europe, including several innovative clocks by Whitehurst. Nevertheless, Brown's products lost nothing in quality to Boulton's, but his catalogue is lost and attributing to him is difficult.

Matthew Boulton Derbyshire spar and ormolu incense burners, *c.* 1770. (Ron Phillips)

Richard Brown blue john urn with Wedgwood plaque of Maria after Joseph Wright. (Christies)

Yet, it was for the making of a successful double-acting steam engine that Boulton was best renowned (*see* Industrial Awakenings chapter), and these were being built under license by another protégé of this Enlightenment coterie, James Fox, at Derby before 1800. The Revd Thomas Gisborne was the devout son of a Derby grandee for whom Joseph Pickford had built St Helen's House, the finest town house of its period north of London in 1767, and was the chief backer and supporter of William Wilberforce in his fight against slavery, a cause quickly adopted by the Lunar circle. When he found one of his footmen to be occasionally lax in his duties, in true Enlightenment style he enquired after the reason instead of dismissing him. He discovered he had an aptitude for machinery, and instead set him up in business in 1782 in City Road, Little Chester, as the proprietor of England's first ever machine tool factory. Not only was he soon supplying Russia with complex lathes, but made spar turning machinery for Brown, who in 1802 took over Joseph Wright's old residence in King Street (once part of St Helen's Convent) and replaced it with a works to house these machines. The firm, under two subsequent ownerships, lasted until the Great Depression, closing finally in 1931. Part of it, unlisted, disappeared beneath a new road in 2009; what remains represents the last surviving purpose-built marble works north of the Alps.

Thus, luxury industry remained the forte of the borough in the mid-eighteenth century, for the spin-offs from the silk mill thrived, too. In the century following the end of Sir Thomas Lombe's patent, specialisation had set in, for three Derby silk mills henceforth wove piece goods of silk, another wove 'silk ferretts, galloons, and doubles' and the rest either still threw silk thread or made silk hosiery.

Brown's marble saw as made by James Fox from Rees' *Cyclopaedia*, 1819. (Author)

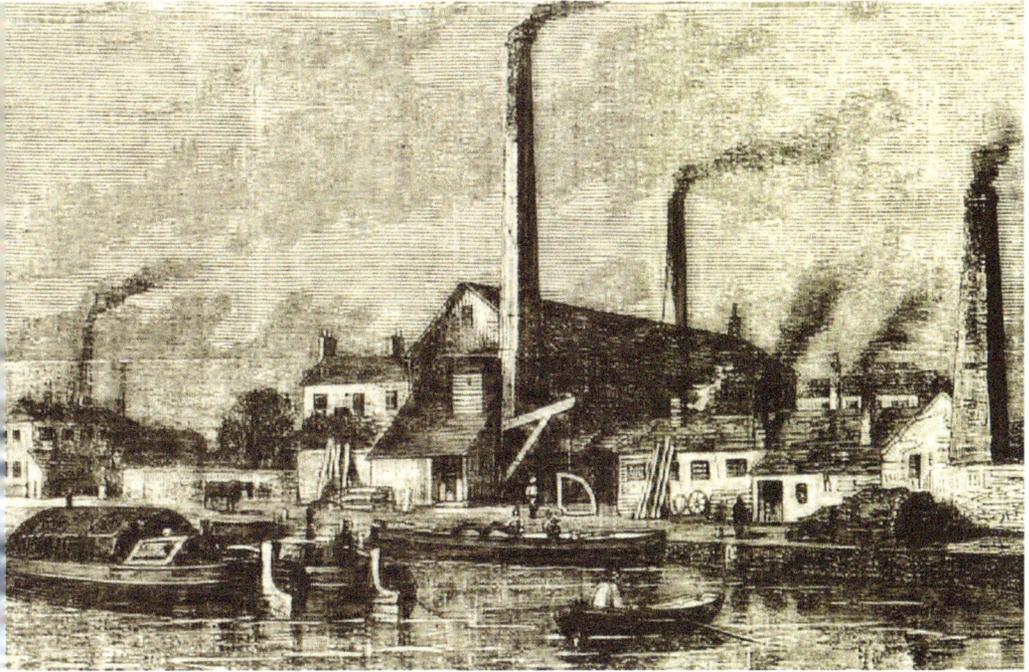

Above: James Fox's Little Chester works, *c.* 1795. (Author)

Right: Richard Brown's original marble works in 1996. (Author)

The first of these was a mill set up in the Morledge in the early 1750s by Jedidiah Strutt (1726–97) to weave 'tram', a rather less refined silk thread than Lombe's method had produced, but a short-lived partnership at about that time encouraged him to diversify into cotton spinning. In 1758, he and his partner William Woollatt were making ribbed stockings in Derby. They later established cotton mills at Belper and Milford using 'Arkwright's principle', adding a calico mill at Derby as well as two cotton mills, one of the latter being a pioneering six-storey building situated in the back garden of Strutt's Derby town house, Thorntree House, St Peter's Street, and built by his gifted son William, on 'fireproof' lines with plaster-encased fir beams and cast-iron supports. Not that this stopped it from burning down twice, latterly in 1878, when it was demolished.

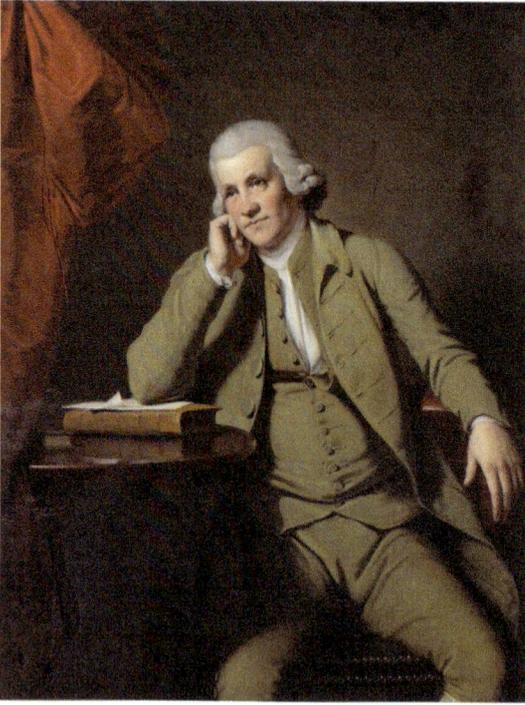

Jedediah Strutt by Joseph Wright, *c.* 1780. (DMT)

Cotton spinning received a tremendous boost, ironically from the insolvency of the bank of John and Christopher Heath in March 1779. The Cockpit Hill pot works closed as a result, although Duesbury managed to find a new backer and buy the china factory back from the receiver in bankruptcy, saving the firm. The receiver in question was Thomas Evans (1723–1814), the son-in-law, namesake and heir of the man who established the rolling mills on The Holmes forty-five years before (see Industrial Awakenings chapter). Having used his patrimony to found a bank, he seems to have gained most from being put in charge of rescuing what assets the Heaths had left. Robert Holden, a landed gentleman of a family from Aston-on-Trent, had borrowed from them to enlarge the house he had acquired when buying the Darley Abbey estate from them (the Heaths having acquired it themselves by foreclosing on a mortgage). He also spent lots of money getting William Emes to landscape the park and Joseph Pickford to enlarge the house. Two years later, he had to buy the entire estate back from the London bankers Boldero & Co., to whom Heaths had themselves mortgaged it (unbeknown to Holden) against a loan to shore up their shaky business. Holden could not afford to redeem all of it, so Thomas Evans himself acquired the land by the Derwent and the village, which included a flint mill (once owned by the family of Robert Bage, the pioneering English novelist) and a paper mill.

These he cleared, rebuilt the weir and began erecting a most ambitious complex of cotton mills. The entire enterprise was underpinned by his eldest son, William being married to Elizabeth, Jedediah Strutt's daughter, and the Strutts' enterprises being supported by loans from Evans's bank. Thus, we are pretty sure that the amateur architect, eldest son of Jedediah, William, designed Evans's house and the mill complex, mainly (following a fire at the first mill in 1782) in an early version of his 'fireproof' method. Later, in 1793, William Strutt duly married Evans's daughter Barbara. Darley Abbey is one of the best preserved Regency mill complexes and model village to have survived relatively intact, despite relentless modern infilling.

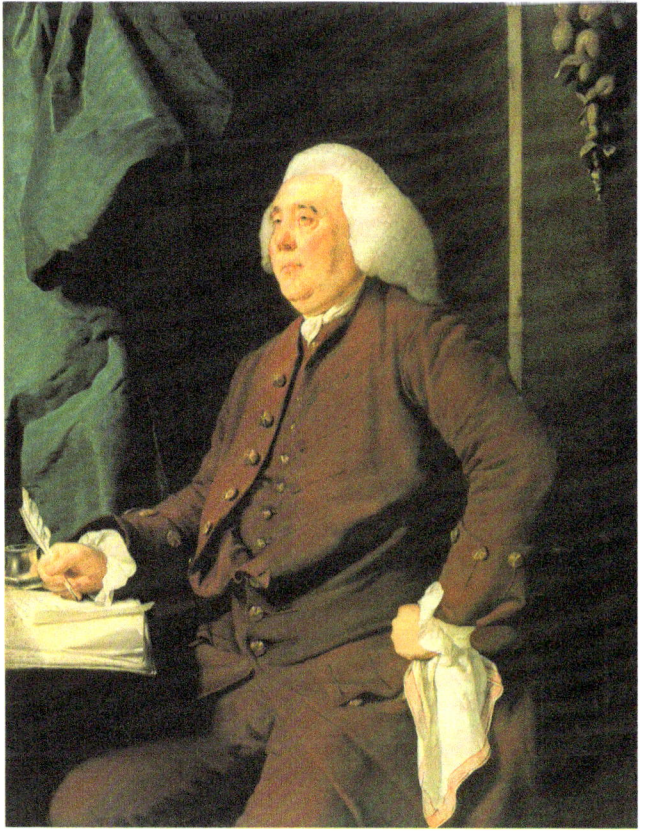

Right: Christopher Heath by Joseph Wright, *c*. 1777. (Private collection)

Below: Darley Abbey, south front, as rebuilt by Pickford in 1778 (photographed, 1960 by the late Edward Saunders)

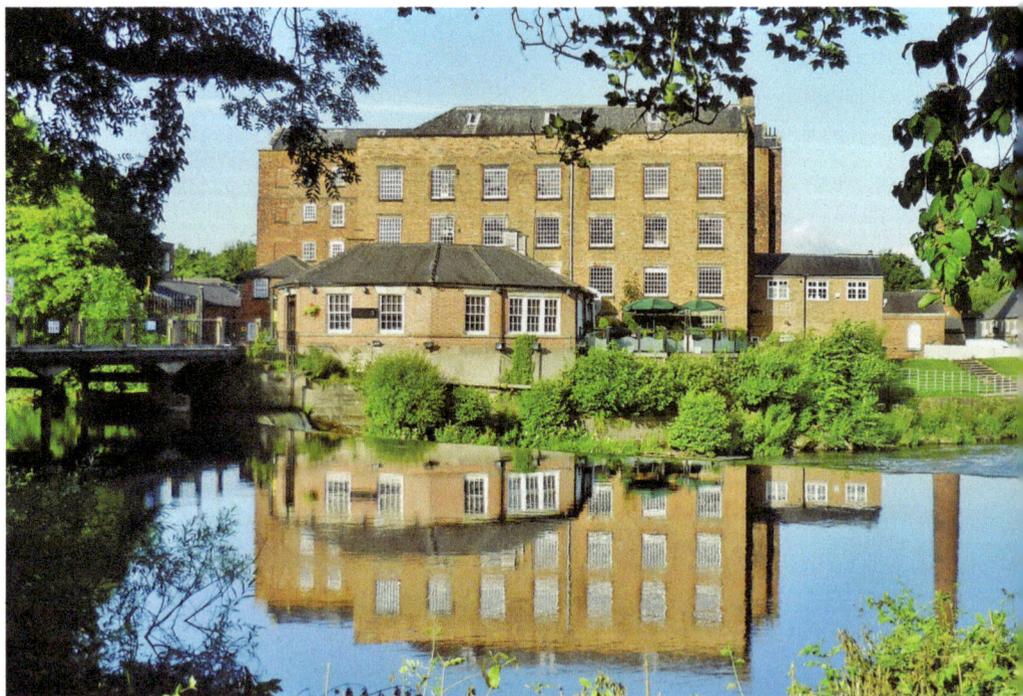

Darley Abbey mills, July 2016. (Author)

The mill village, Darley Street, looking south, January 2017. (Author)

Yet it must not be forgotten that in dealing with silk, china, cotton, calico and spar ornaments, we are dealing with the 'high-end' consumer products of their day. Thus, it will occasion little surprise to know that in 1806 a tape trimmings industry was established at Little City by Riley, Hackett & Co. (whose workers' housing was probably the grimmest of all in Derby), and in 1811 Boden and Morley established a vast lace mill at Castle Fields, London Road, using machinery derived from that pioneered in Loughborough by the Heathcoats.

Another high-end product was lead shot. Since Roman times lead had usually been smelted into transportable form near the point of extraction and carried away. William Cox, son of a Brailsford schoolmaster, set up a leadworks in The Morledge in 1781 to process lead for water tanks, urns and so on. In 1809, he erected a castellated tapering 70-foot tower down which molten lead was poured through a grid allowing it to cool into round globules while descending. The shot tower survived as a Derby landmark until 1931. A concentration of high-quality gun makers also arose in Derby at this time to take advantage of the works.

Nor were the transportation demands of the Derbyshire gentry ignored. In 1795, Charles Holmes migrated his coachbuilding works from Lichfield to Derby, where he quickly established a national reputation for building the very finest quality conveyances, from the state chariot built for the likes of Sir George (Harpur-) Crewe, Bt of Calke (where several examples of the firm's workmanship survive) and 1st Earl of Craven (now at Arlington Court, Somerset), to gigs, flys, landaus and buggies. Appointed coachbuilders

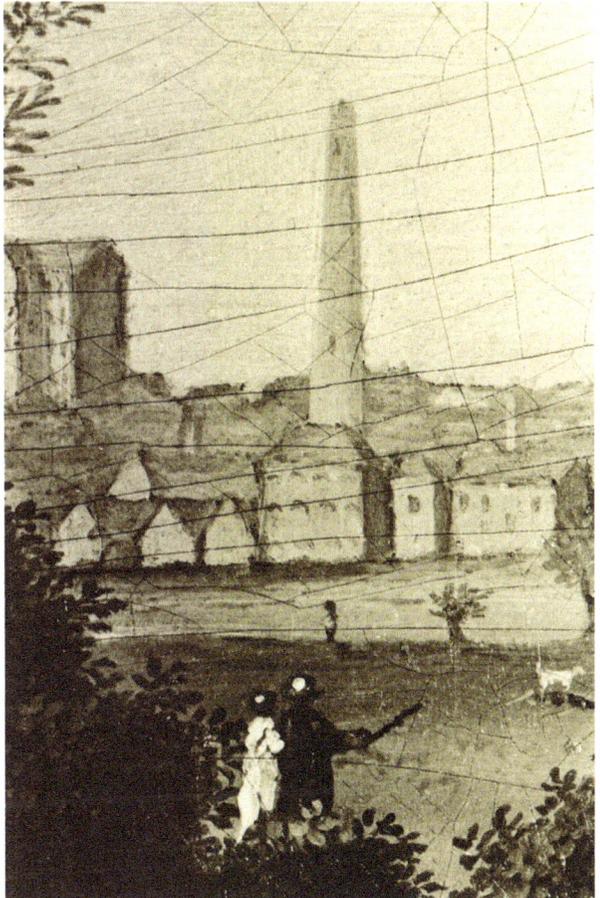

Strutt's fireproof mill and shot tower detail after William Corden, 1818. (Private collection)

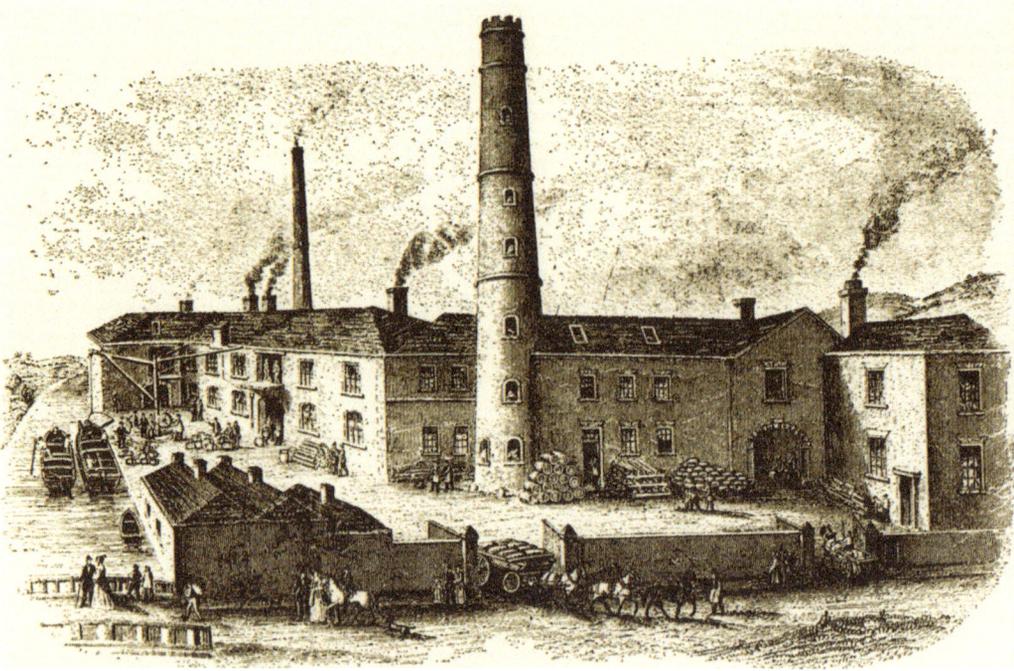

Above: Cox's lead works, The Morledge, Derby, *c.* 1820. (Author)

Left: Percussion cap pocket pistol by Weatherhead & Co., Derby, *c.* 1836. (Mellors & Kirk)

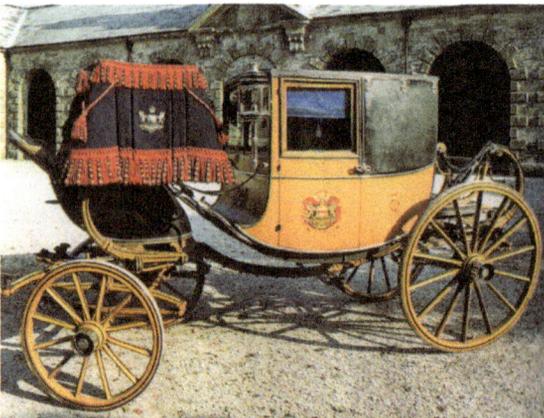

Holmes & Co., the Craven state chariot, 1844. (National Trust)

to the Prince of Wales (later George IV) and with a showroom just off The Haymarket in London, they flourished in an impressive Regency works on London Road. From 1900, they also built motorcar bodies having amalgamated in 1883 with rivals Sanderson & Co. (as Sanderson & Holmes) becoming also prestige car concessionaires, Derby-made Rollses becoming a staple of their trade. Coachbuilding failed to survive the war, but the firm survived to 1963.

Nor was demand for architectural embellishment confined to lead garden urns, wrought-iron balustrades and turret clocks. The fashion, for those wishing to build a country villa at the end of the eighteenth century, was to build in brick (being cheaper than stone) and cover the result with a newly invented permanent render called Roman cement, which produced a durable smooth finish and could be grooved and painted to resemble rusticated blocks or jointed ashlar. The formula was developed by John and Joseph Brookhouse, who founded a works on The Morledge, beside Cox's lead works, using ground-up gypsum mined from alabaster pits in Chellaston, now a southern suburb of the town. The firm also made plaster of Paris and, as F. & R. H. Johnson, survived into the nearly years of the twentieth century.

The final product that was made in Derby specifically for the prestige building trade was cast iron. In contrast to the plethora of iron foundries that arose in Derby after the coming of the railways, Thomas Wheeldon's foundry, the first industrial rather than craft one, was founded in St Peter's Street in 1783 to make items of use in the building trade or to embellish parks and gardens. St Peter's Street being far from ideal for iron founding, the concern was swiftly moved to the banks of the Derwent, where it became the Derwent Foundry, where Wheeldon was joined by Thomas Glover, who moved the concern to the park of St Helen's House, by now the home of the philanthropic Whig William Strutt FRS, who made land available for industry and building between his house and the Derwent in 1818. At this stage they were making staircase balustrades, patent sliding louvered metal jalousies, columns, urns, seats and other architectural embellishments, many of which went to beautify the villas of the Derby entrepreneurs.

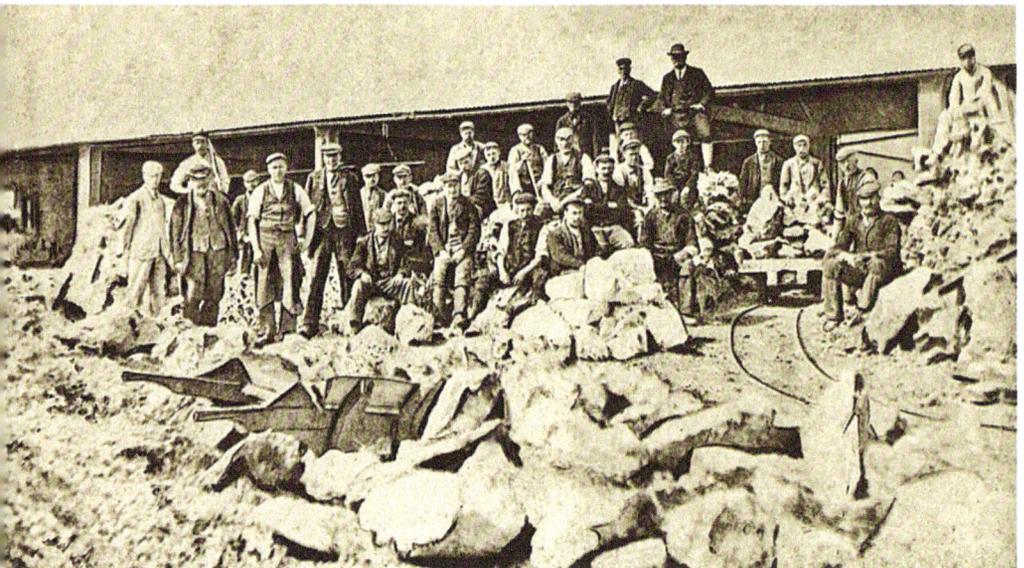

Workers at an alabaster pit, Chellaston, 1891. (B. Foreman)

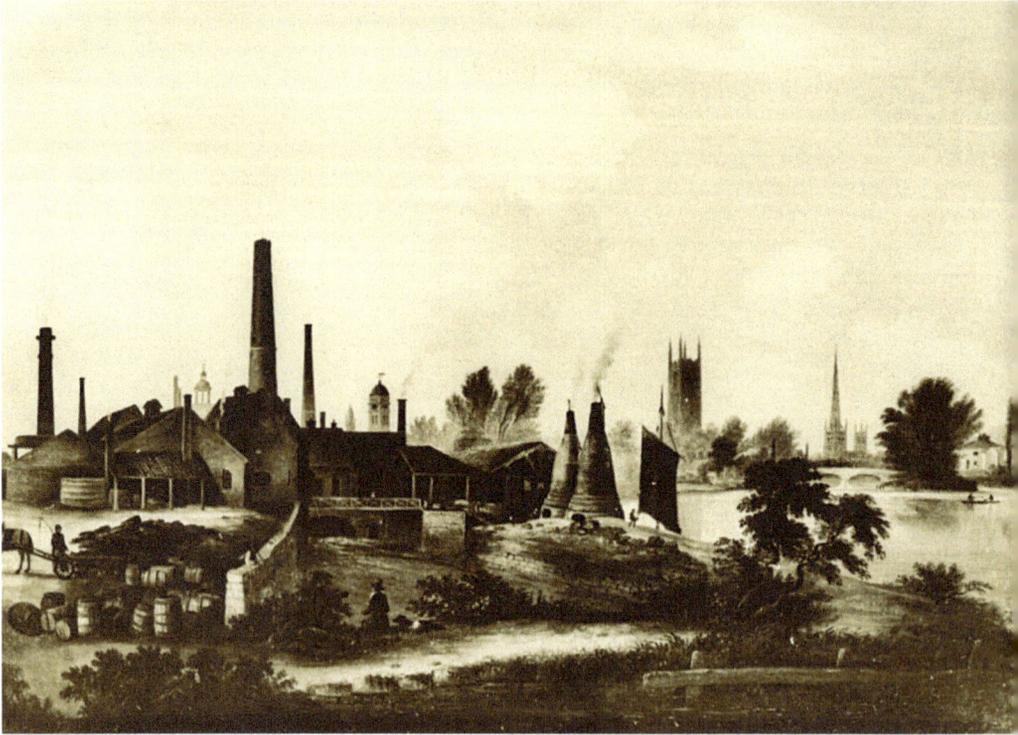

Above: Morledge, Brookhouse's plaster works, *c.* 1850. (DMT)

Left: Wheeldon & Glover foundry, cast-iron garden urn, *c.* 1817. (Bamfords Ltd.)

Derby-made cast-iron sliding jalousies, Highfield House of 1819, August 2011. (Author)

Thus despite the emphasis on the luxury end of manufacturing throughout the eighteenth century, the seeds had been sown for a transition to heavy industry, with iron founding and a lead works jostling with houses, shops and mills between the town centre and the river. Certainly, the increasing insalubriousness of the centre of Derby had led to the spate of suburban villa building and had forced the Duke of Devonshire, as borough hereditary High Steward, to forsake his Palladian town house in Corn Market for the relative calm of the Judges' Lodgings in St Mary's Gate. The scene was set for the next stage of Derby's industries.

REGENCY AND RAILWAYS

While the arrival of the copper and lead works and an iron foundry were the straws in the wind for the transformation of Derby's industrial base, it was not really until the arrival of the railways in 1839–40 that heavy industry began to predominate. Not that the railways were the first attempt to improve the transport infrastructure of the borough. We have seen how George Sorocold had engineered the Derwent Navigation, which much aided the transport of bales of silk thread from the silk mill and more fragile goods, like William Duesbury's china. In 1792, Benjamin Outram had engineered the Derby Canal, which linked the Trent directly south of Derby to a canal basin beside Cockpit Hill at

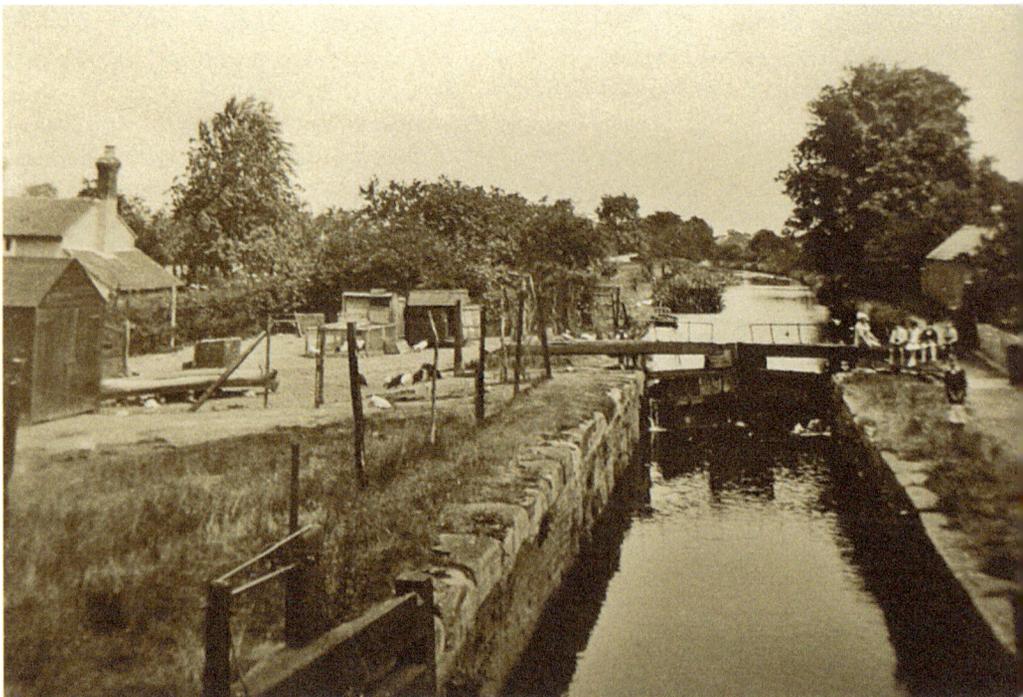

Derby Canal: Frank Scarratt's view of Shelton Lock in 1934. (Author)

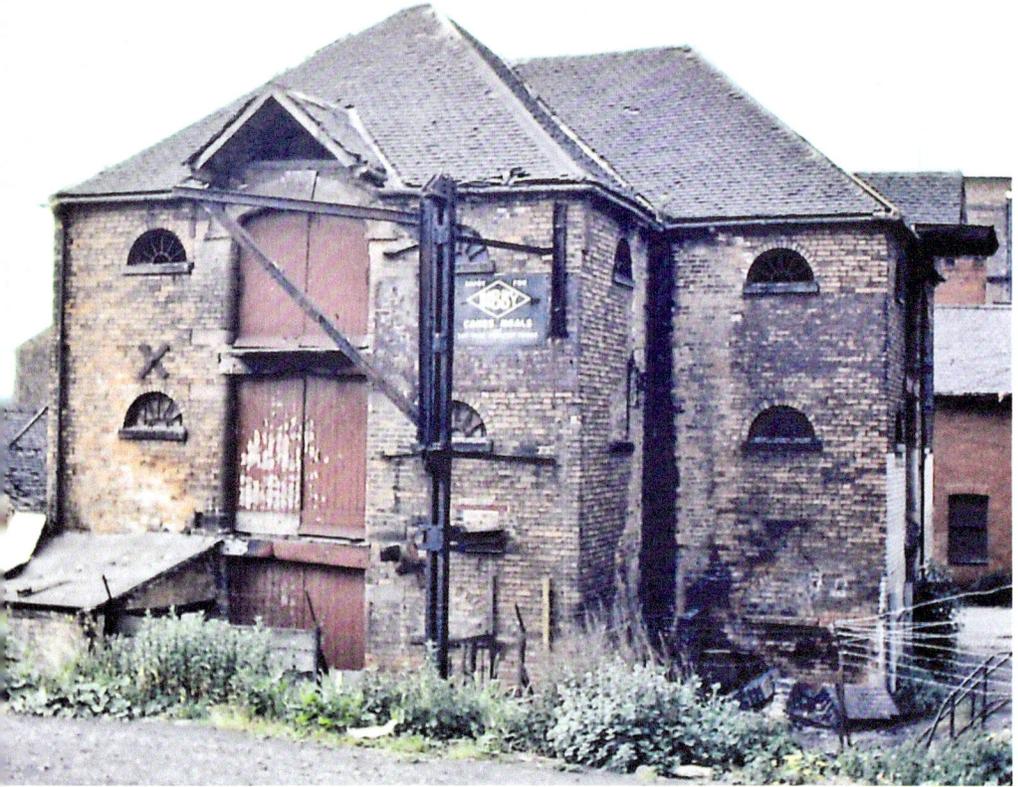

Derby canal basin. Bridgewater Warehouse of 1820, prior to demolition, 1977. (Author)

the south end of Morledge. Thence it crossed the Derwent on the level (thanks to a large weir created just south of the line of the cut) formed another basin beside Nottingham Road before running east to reach the Erewash on the Nottinghamshire border. Where it reached Nottingham Road, beside a fine Regency terrace called Derwent Row, an arm ran north-west to reach the Derwent again immediately south of St Mary's Bridge, itself simultaneously replaced with an elegant classical design by Thomas Harrison of Chester, thanks to the Second Derby Improvement Commission, chaired by the ubiquitous William Strutt. Half a mile further east, another arm ran off due north as far as Little Eaton, where a tram road – always horse-drawn and called the gang road – ran north-east to Denby Bottles, where it served several coal mines.

This innovation will have been a factor in Boden and Morley locating their lace mill in Derby and probably encouraged others. Yet a fundamental problem was that Derby was hemmed in by landed estates, and room to expand was at a premium, which is why the first iron foundry was established in busy St Peter's Street. A third Improvement Commission was therefore set up in order to sell off Nuns' Green, former convent land given to the town by Mary I in 1555. This lay behind the elegant Georgian houses on the north side of Friar Gate (built under the aegis of the first such commission in 1768), stretched almost to the Kedleston Road and was bisected by Markeaton Brook. The move faced fierce opposition from those who (rightly) saw that the land would rapidly become covered in industrial buildings and low-grade housing, rather than further villas, simply because the brook represented a power source.

Little Eaton gang road, looking north at Jack O' Darley's Bridge, 1908. (DMT)

Despite protestations to the contrary, this is precisely what happened, slowly at first, but increasingly rapidly from the 1820s. William Strutt, whose family's workers' housing was of exemplary standard, thought, as a high-minded liberal, that those who developed the land would build to the same standard. Human nature, of course, is neither high-minded nor particularly liberal and most of the housing in what became Derby's seedy West End was of abysmal quality, and became the subject of slum clearance after the Second World War.

The first mill of the new development was a large corn mill erected by Francis Agard, who gave his name to the street that divided it from the rear of the grand houses on Friar Gate. Another early one was the first steam-driven silk mill, erected by Thomas Bridgett & Co. from 1818 and expanded thereafter. Like Strutt's fireproof mill in the town centre, it was 7 storeys high and, having been saved by spot listing in the 1990s, is still a notable landmark today, albeit converted into apartments. Neighbouring Peet & Frost's mill was nearly as big, and the epicentre of a widespread strike among silk workers in 1833 called the 'silk mill lockout'. Again, much of the building remains, but modern day trades' unionists prefer to mark the anniversary of this landmark in labour history by hanging a wreath on Lombe's silk mill, despite the fact that its workers were largely uninvolved – it is, of course, much less far to march.

The continuing march of industry, crammed in around what was still a county and market town, flagged up the need for further improvements to the transport infrastructure. Thus, in the 1830s, three railway schemes were being hatched in the region: the Midland Counties Railway (MCR), intended to link Nottingham with, among other places, Derby; the Birmingham & Derby Junction Railway (B&DJR), planned to enable people to travel from Derby to London via Birmingham; and the North Midland Railway (NMR) linking Derby with Leeds via Sheffield.

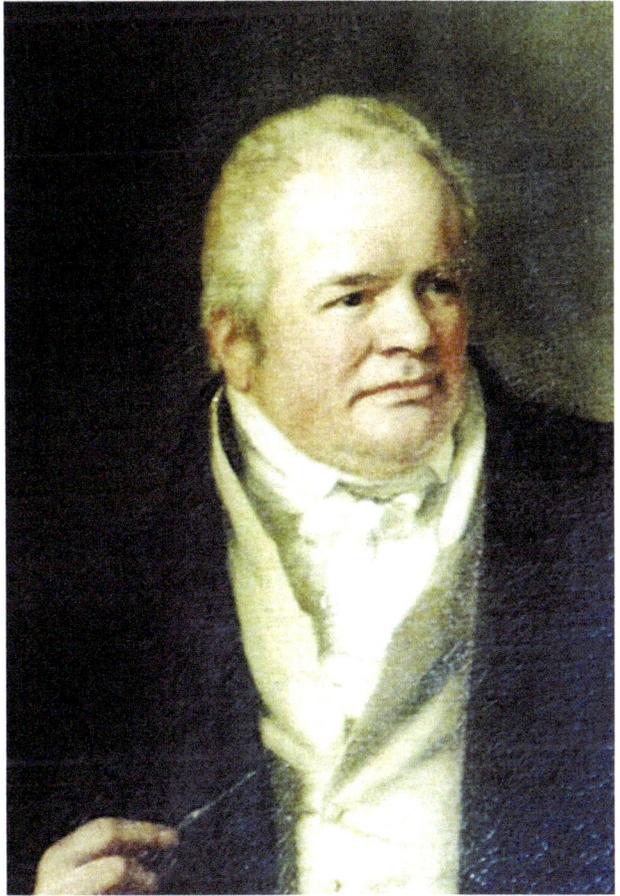

Right: William Strutt FRS by R. R. Reinagle, 1813 detail. (Derby City Council)

Below: West End housing. Five Regency cottages in Whitecross Street are cleared, 1966. (Author)

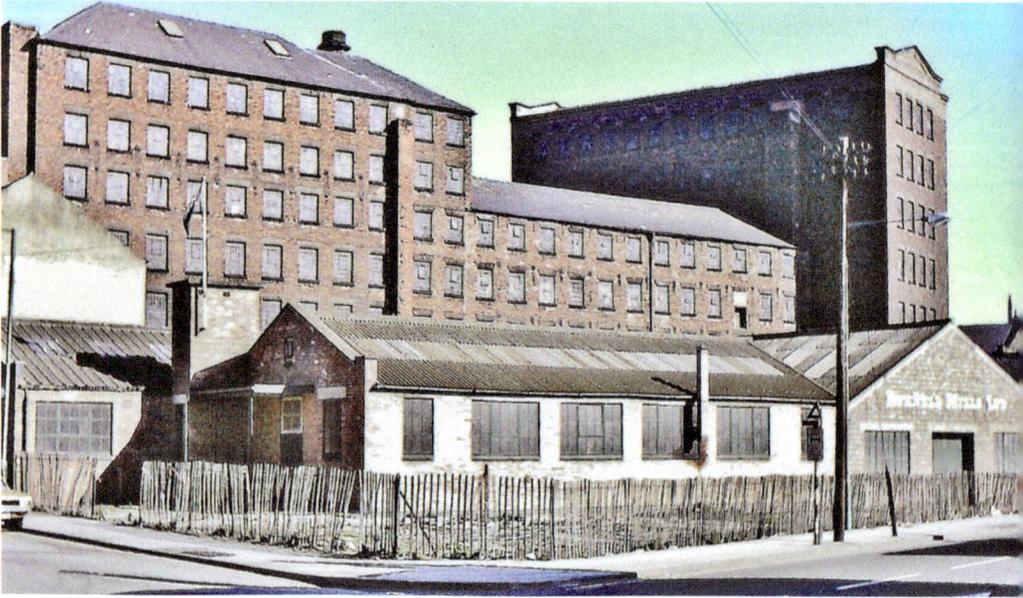

Brook Street, former Bridgett's steam silk mill, 1977, now housing. (Author)

Carved arms of the NMR from the Trijunct Station found at Littleover Old Hall. (Author)

These all came to fruition in 1839–40. At first the MCR wanted a station on the site of the Every family town house on the east side of the Market Place, but the Borough Council were having none of it, and urged the three rival companies to come up with a joint site. Eventually, one south of the town was acquired on some water meadows adjoining The Holmes called the The Siddalls, then the town racecourse. Here a joint station with a single shared platform of enormous length was built called the Derby Trijunct station, linked to London Road by Station Street. Probably because of its sounder financial backing, it was the NMR's architect who created the station, Suffolk-born Francis Thompson (1808–95) recruited from employment in Canada by the engineer for the line, Robert Stephenson.

Thompson designed the long, elegant, neoclassical façade of the station, the strikingly well composed Midland Hotel (1841), the octagonal and innovative locomotive round house and offices, three streets of workers' housing immediately north-east of the station, with a purpose-built inn at the north end, called The Brunswick. Adjoining the roundhouse was the NMR carriage shed and, at right angles, the MCR's architect William Parsons built an equally well-proportioned locomotive shed with fenestration on its long site set in a blind arcade of unexpected elegance.

This ensemble, complete by 1843, remained for 140 years the finest and earliest group of top-quality railway buildings in Britain, despite numerous enlargements made to the station itself. The tragedy was that Sir Peter Parker, the chairman of the nationalised concern British Rail, saw it in decay (brought about through acute neglect by the organisation he chaired) while escorting a delegation from China, and ordered its immediate replacement. The successor building is of poor quality and, despite the statutory protection accorded the remainder of Thompson's masterwork, its loss gives what is now an important conservation area the appearance of a mannequin with a front tooth missing.

The three new railway companies, which began services in 1839 (the NMR took until 1840 to get started due to the challenges of its route), all struggled financially, and the NMR involved the famous George Hudson of York, who quite rightly realised that if all three joined

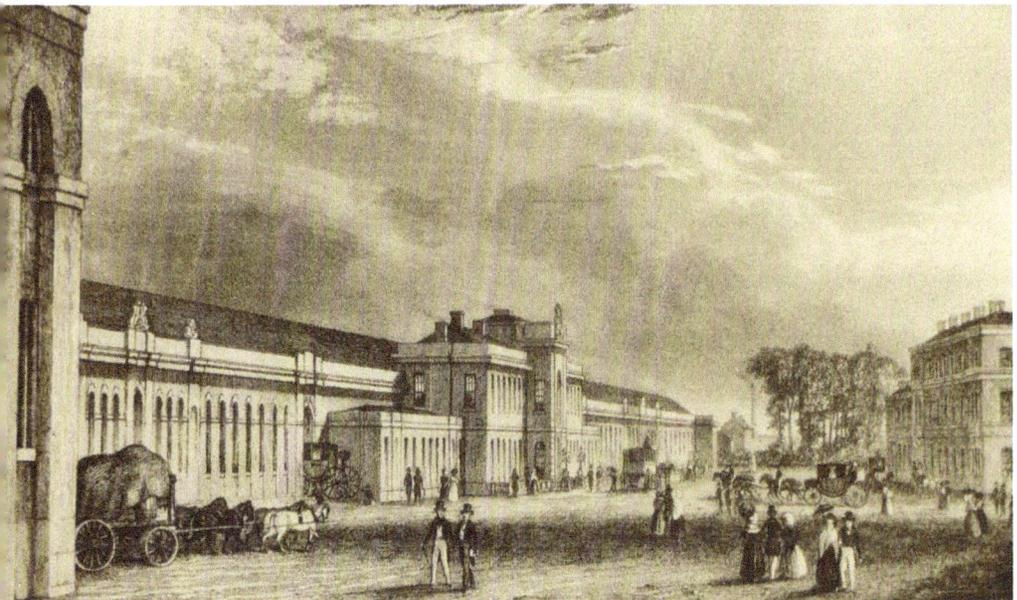

Trijunct Station and Midland Hotel, 1842. (Author)

Above: Midland Hotel, west (garden) front in February 2015. (Author)

Left: NMR roundhouse as restored, June 2011. (Author)

NMR roundhouse entrance and clock tower, March 2014. (Author)

Restored NMR cottages, Leeds Terrace, June 2014. (Author)

MCR locomotive shed, as restored for Derby College, June 2011. (Author)

forces, they would have a chance of success. Hudson, although later vilified and ruined by allegations of corruption, was an exceptionally clear-sighted man, and his creation of the Midland Railway (MR,) amalgamating all three companies in 1844, was an unqualified success throughout the seventy-nine years of its existence.

At first, locomotives and rolling stock were built by outside suppliers, but from 1851 a decision was taken to appoint a locomotive superintendent and build bespoke locomotives and rolling stock on site, at first using the buildings near the roundhouse which, after all,

had been intended to cater for three companies. Within a decade or so, however, the works expanded, a carriage and wagon works were added and finally a signalling facility. Here were built for over 130 years some of the most notable locomotives.

The coming of the MR had several knock-on effects. The Litchurch area of the borough began to expand, with streets of terraced dwellings, which housed not only the workers of the railway, but those who toiled in the foundries of the MR's suppliers for, as soon as stock was being built on site, suppliers were needed to furnish parts, specialised components and other requisites of the railway company's works.

Yet when the MR set up their works, Derby already had eleven foundries. Even in 1800, Wheeldon's enterprise had been joined by John Harrison's foundry, which specialised in mileposts and (strange contrast) boilers, initially domestic ones, in collaboration with William Strutt, who was busy developing ideas tested a generation earlier by John Whitehurst to provide running hot water and heating systems. These Strutt had applied at St Helen's House and at the Derbyshire General Infirmary, which he co-designed between 1806 and 1810. It also included lavatories that flushed when the occupant opened the door to leave, another Whitehurst idea.

Not that the MR had a rail monopoly in Derby, for the North Stafford Railway (NSR) ran trains into Derby Midland Station from Stoke, and from 1878 the Great Northern opened a line from Ilkeston to Egginton Junction (for Burton-on-Trent), which, while never particularly profitable, survived until 1964 (for passengers) and 1968 (for freight). The company's ornamental bridge over historic Friar Gate (currently in decay) was cast by Derby foundry Handyside & Co. The GNR station at Friar Gate, with its titanic bonded warehouse (today also a decaying shell), was a tour de force of efficient freight handling in its day.

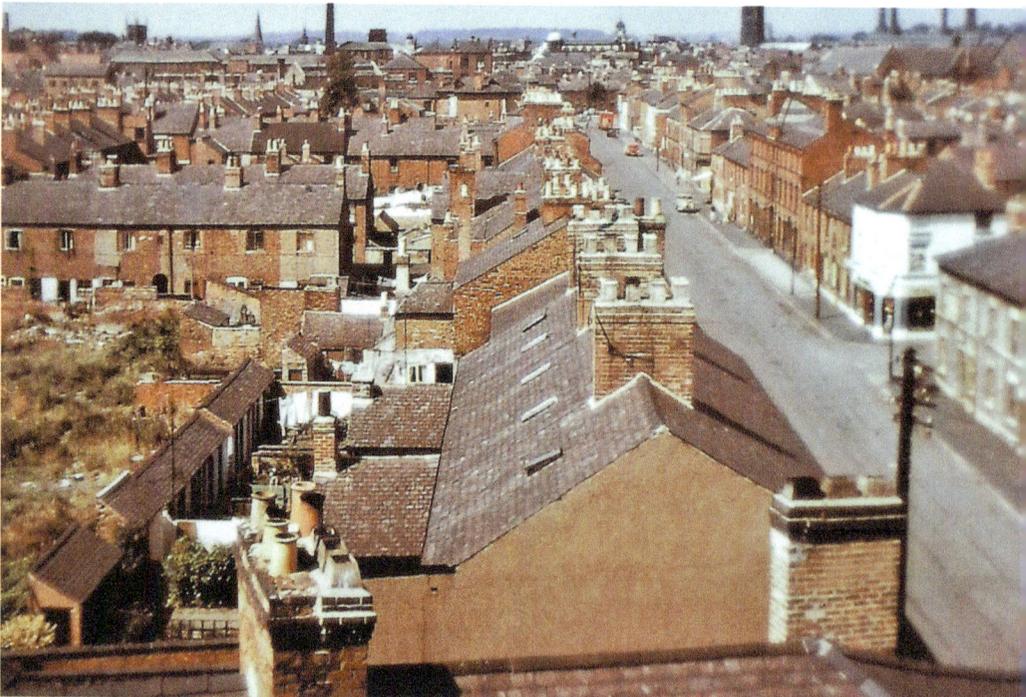

Park Street, Castlefields, photographed by the late Don Farnsworth, 1965, now redeveloped. (Author)

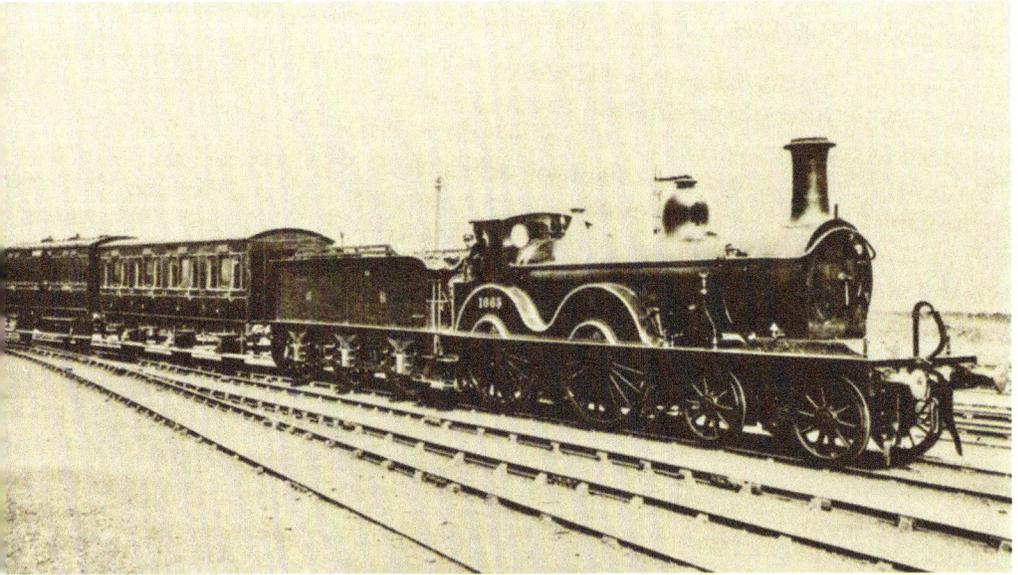

Above: MCR 6-foot 8-inch 4-4-0 No. 1665 photographed when new, 1883, by Thomas Scotton. (DMT)

Right: Early cast-iron milepost, Harrison's foundry, Duffield Road, June 2008. (D. Maltby)

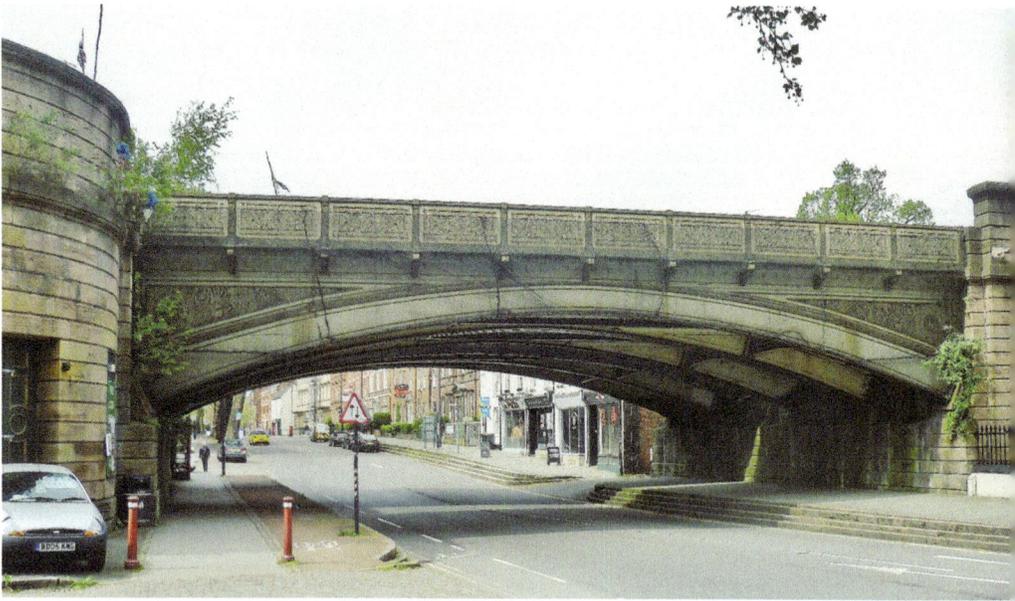

Handyside's GNR bridge, Friar Gate, in decay, April 2017. (Author)

Gutted shell of ex-GNR bonded warehouse from the south-east, 1998. (Author)

THE COMING OF HEAVY INDUSTRY

A good number of the pre-railway foundries were fairly small concerns, but many took flight on the back of the railway boom and became major players. Wheeldon (later Weatherhead) & Glover, for instance, turned from making architectural ironwork and street furniture but, having been taken over by Andrew Handyside in 1847, rapidly turned to making pillar boxes (for which they became famous) and then to heavy engineering: bridges and stations particularly. Handyside had trained under his uncle Charles Baird in Russia and had aided former Lowell (Massachusetts) locomotive builder G. W. Whistler in engineering the bridges of the St Petersburg to Moscow railway from 1841. He came to Derby through the good offices of Derby mill owner Samuel Job Wright, who traded silk in St Petersburg.

Andrew Handyside cast-iron pillar box, Table Mountain, RSA, 2002. (Author)

BRITANNIA FOUNDRY,
DERBY.
—
ANDREW HANDYSIDE,
ENGINEER AND IRON FOUNDER,
RAILWAY WORK OF EVERY DESCRIPTION.
WATER CRANES,
WHEELS, COAL TRUCKS, &c.
CASTINGS. PLAIN AND ORNAMENTAL.
An extensive assortment of Patterns in
WINDOWS, COLUMNS, GIRDERS, PALISADING, &c.

Andrew Handyside
advertisement, 1852.
(Author)

Handyside cast-iron ornamental
fountain in Derby Arboretum.
(Author)

Handyside found himself in competition with the Haywood family whose Phoenix Foundry on the east bank of the Derwent began modestly but soon began making similar products, although they were better known for civil rather than railway engineering, having made the iron roof of the Derby Market Hall (1864–66) and a remarkable cast-iron façade for their own ironmongery outlet in Iron Gate, designed by the architect Owen Jones.

A lot of the new foundries established in the mid-nineteenth century were specialised. Thomas Crump grew out of a plumbing firm, and developed a patent water closet, which was patented only months after the efforts of his better-known London contemporary Thomas Crapper (depriving us of the opportunity of going for a crump, as it were) but later branched out into gas engineering. This was in turn driven, once again, by the enterprise of William Strutt and his two brothers, who founded the Derby Gas Co. in 1820. Their engineer, William Wigston, was a gifted innovator who had improved some of the instruments for recording and measuring pioneered by John Whitehurst and his two successors, but for installations, it was to Crump that he turned. His reputation was made when he landed the contract to fit Derby Trijunct station and other railway installations around it for gas lighting. The firm continued in the plumbing trade until the 1960s in Friar Gate. The Crumps were also associated with the Haywoods in several projects.

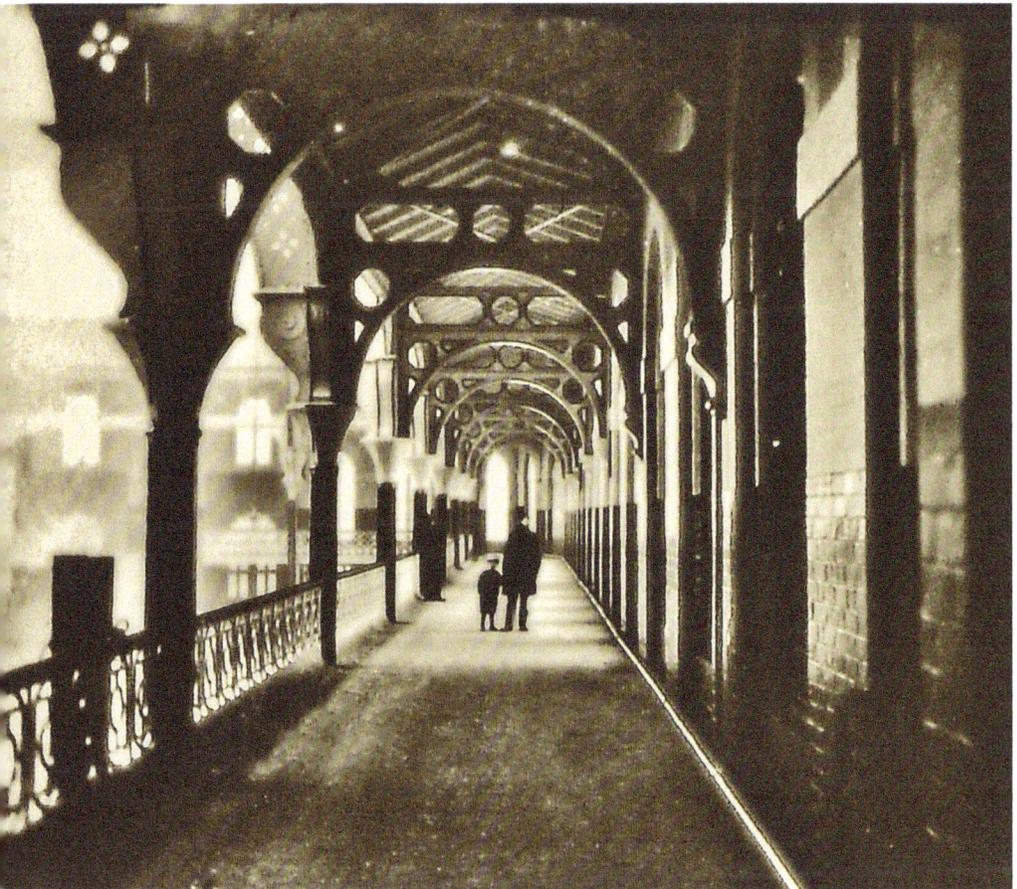

Phoenix Foundry cast iron, Market Hall, Keene photo, 1864, with James Haywood and child. (DMT)

Crump advertisement, 1878. (Author)

Eastwood and Frost was established in 1852, and specialised in railway wagon wheels, and both were later associated with Thomas Swingler (1819–73), who established a separate foundry making axles for the railways, but from 1867 with Eastwood as Eastwood and Swingler, a major player in supplying the Midland with components. Others included Abell's, making silk throwing and weaving machinery, and Brown's foundry, which specialised, like Chartres in Little Chester, in lighting standards and other street furniture but who are best remembered for casting some memorable (and surviving) iron bollards. George Fletcher, who had been an apprentice of George Stephenson no less, set up a foundry in 1860. He had travelled in the Americas and produced steam engines and, in contrast, sugar-refining machinery. One of his Grasshopper steam engines survives in Derby's Silk Mill Museum. In 1956, the firm was purchased by Booker McConnel and eight years later merged with Stewart's of Glasgow (another Booker McConnel firm), becoming Fletcher and Stewart, which survived in Derby to 1983.

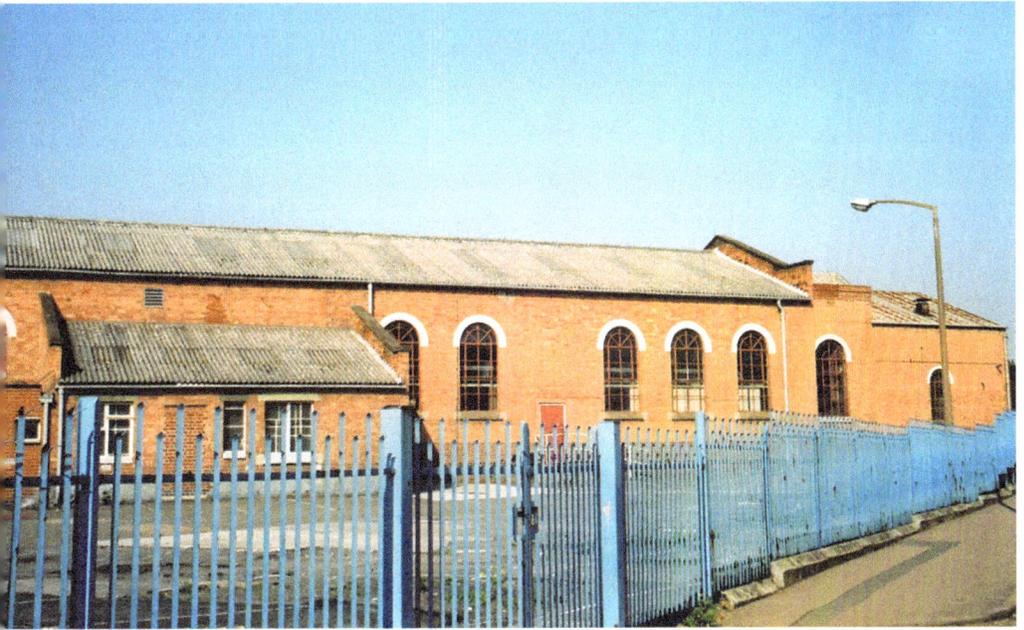

Former Eastwood & Swingler works, Osmaston Road, 2006. (Author)

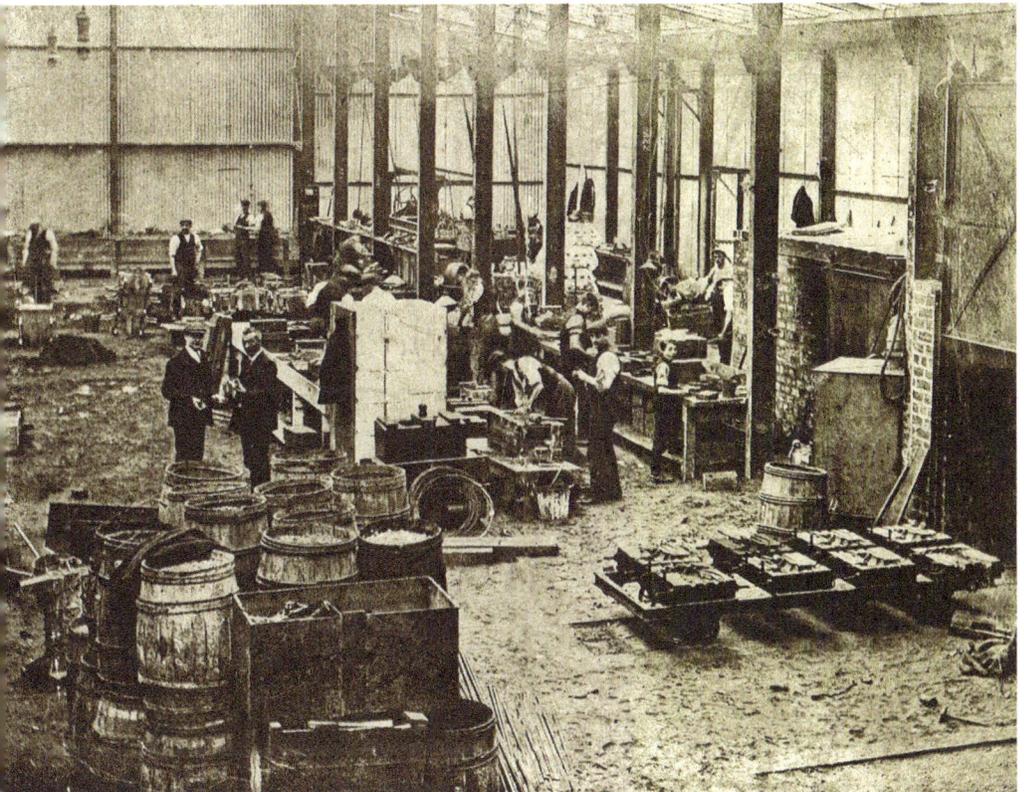

Abell's Foundry interior, 1907. (DMT)

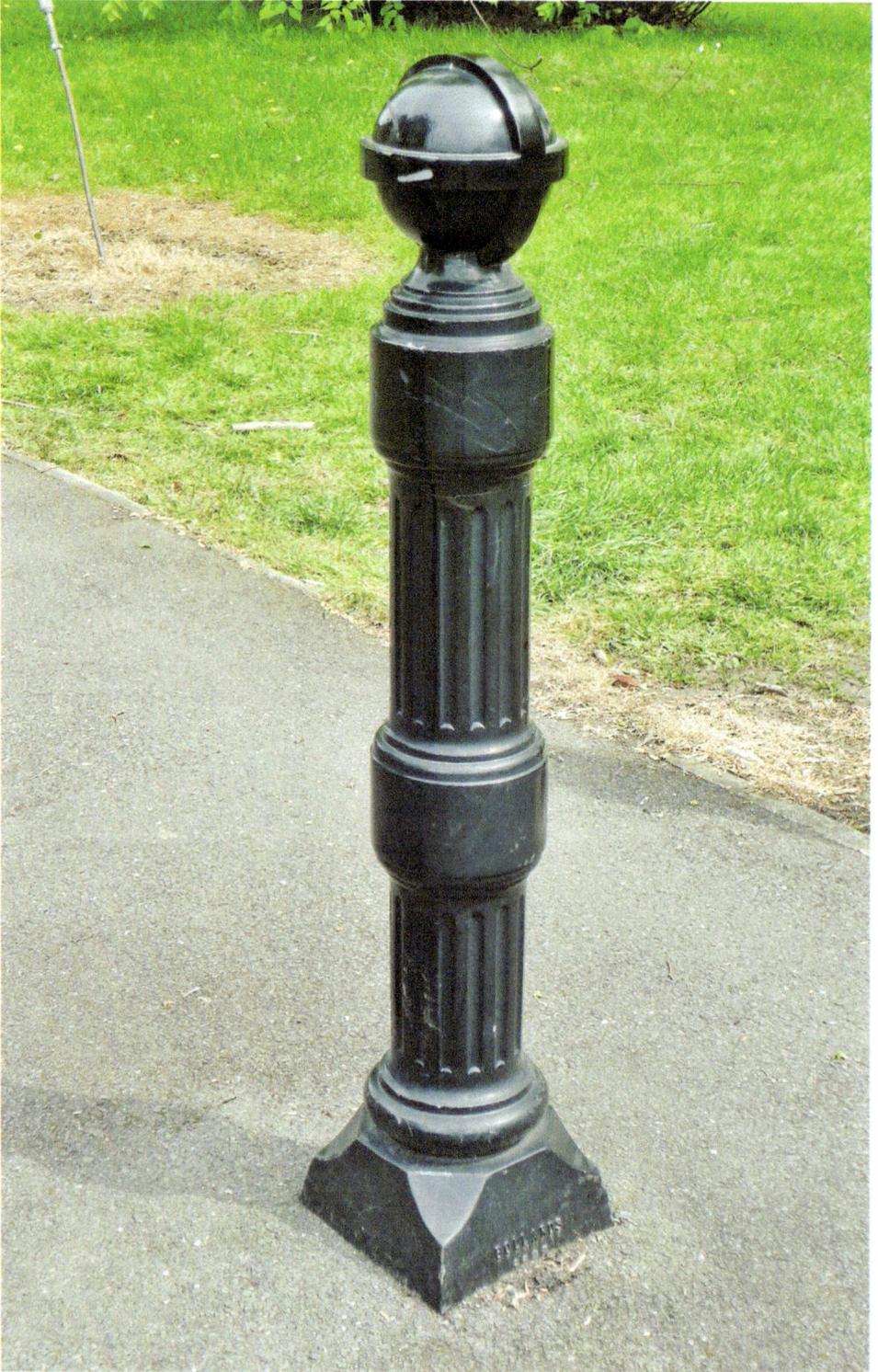

Brown's Foundry bollard in Chester Green, April 2017. (Author)

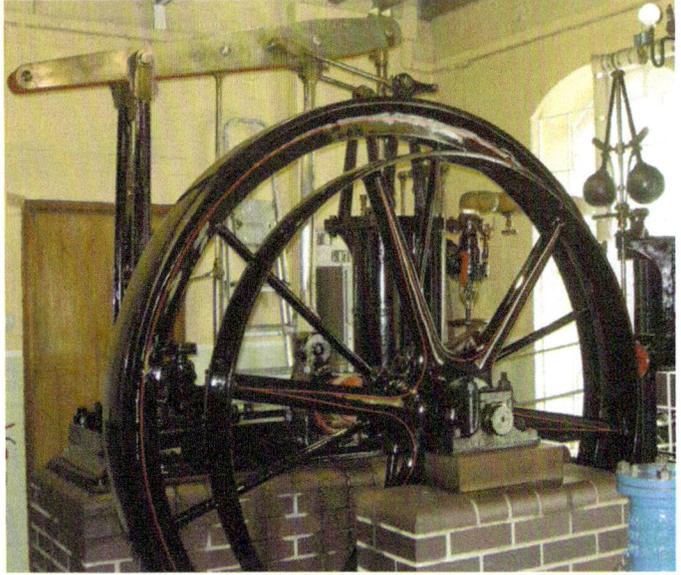

Fletcher & Co.
Grasshopper engine,
Derby Museum. (DMT)

Some foundries specialised in grates, stoves and domestic ironware, such as Russells, Henry Fowkes and George Jobson, although in the twentieth century the latter diversified into casting for motorcar engines and, as Qualcast, lawnmowers. Several other firms also made general products of this sort. Of course, railway building also required brass castings, and indeed there had been a handful of small brass foundries in Derby by the 1830s, making domestic fittings like door furniture, candlesticks, clock plates, wheels, even whole movements. Several members of the Whitehurst family worked as braziers to supply their cousins John Whitehurst II and III with components, especially as the profusion of mills had led to an increase in demand for turret clocks, simple hook and spike wall clocks and above all, noctuaries. The latter, often called watchman's clocks, were simple timers with pegs around the edge of the dial. When a watchman passed one on his rounds he depressed a lever in the side of the case, a peg being depressed and remaining so. When the supervisor had checked at what times the watchman had passed, the pegs reset when passing over a cam. William Strutt, who claimed to have developed these simple but effective devices with Erasmus Darwin in the 1790s (but for which the first John Whitehurst probably is due most credit), espoused these to check patrols while the General Infirmary was building, and nineteen were placed in all-weather boxes at strategic points around the borough to regulate the watch patrols, enabling manpower to be cut by half, which much impressed the Municipal Corporations commissioners when they inspected in 1834.

Needless to say, the railway vastly increased the demand for brass, for bearings and other non-ferrous parts in rolling stock building, as did the expansion of the gas lighting in the town. Thus, in 1844, a large-scale brass foundry, also mainly associated with the railway, was established by George, the father of Alderman Sir John Smith (as he later became) at an address in Nuns' Street, moving under the tutelage of the son to King Street in 1862. Much later the firm, which passed to Sir John's nephew Albert Ottewell in 1897, moved to Cotton Lane where it could better serve the railway. The firm, locally called 'Brassy Smiths', once operated foundries all over the UK, and also went in for high-quality light fittings and domestic decorative fittings, but finally closed right at the end of the twentieth century. Their craftsmen made the superb lectern in the cathedral in 1873.

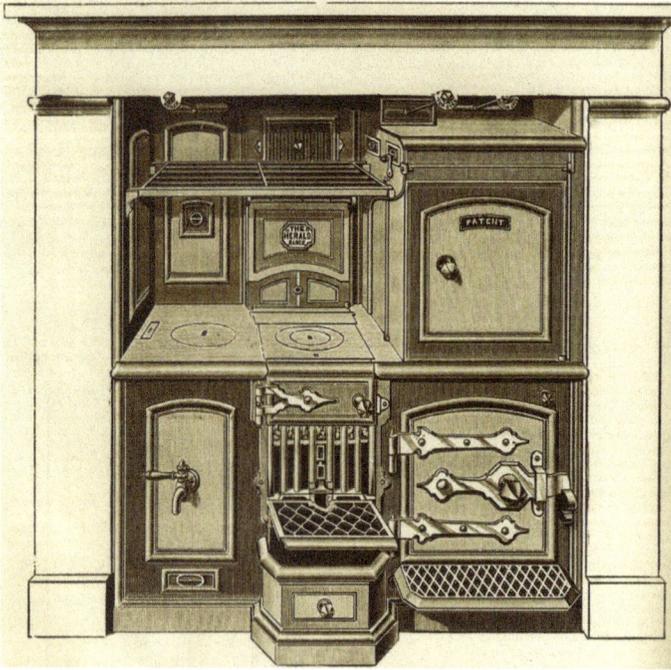

Russell's Peel Foundry's
Herald range, *c.* 1880.
(Author)

Cast-iron Duke of
Wellington plaque,
Jobson's Foundry.
(Author)

Reverse inscription
on plaque dated
15/11/1854. (Author)

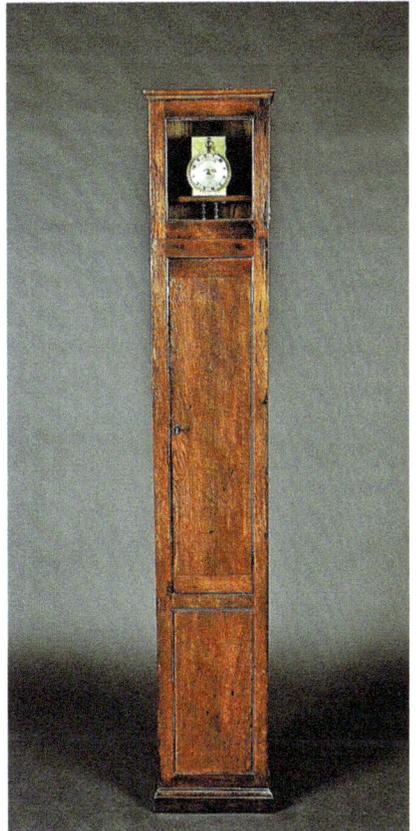

John Whitehurst II watchman's clock of 1807.
(Bamfords Ltd)

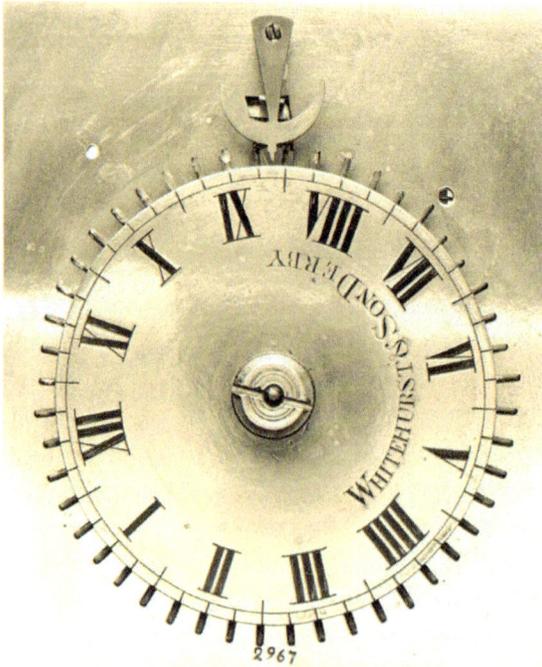

Dial of similar clock of 1822. (Author)

Brassy Smith advertisement, 1891. (Author)

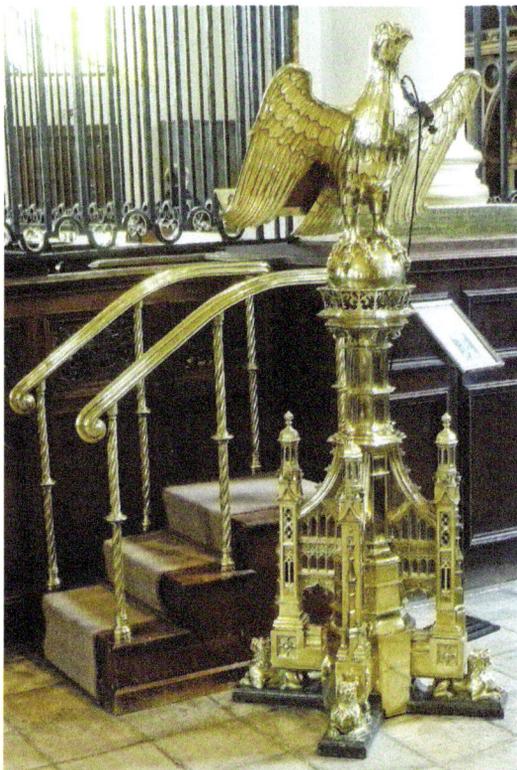

Orme presentation lectern by Brassy Smiths, Derby Cathedral, 1892. (Author)

In 1874, Francis Ley established his malleable castings foundry on Osmaston Road, beside the old B&DJR main line. Francis Ley himself, born at Winshill in 1846, eschewed living cheek-by-jowl with his works in Derby or any part of civic life and settled at Epperstone Manor, Nottinghamshire. His change of calling from minor gentry to foundry man occurred at fifteen when he decided to train as a draughtsman with Andrew Handyside, leaving at twenty-eight to set up on his own. Ley had been sufficiently attuned to future trends to follow Fletcher in visiting the USA, and eventually obtained the rights to the manufacture, under licence, the Ewart Chain Belt. He also brought back an enduring love of baseball, adapting a ground beside the works and founding a team to play in the nascent (and short-lived) English League. When baseball failed to grab the imagination of its potential audiences, he invited the Derby County FC to share the ground and it was their home until 1997. By his second marriage to a daughter of John Jobson, he cemented an alliance between two of the foundry families whose concerns were to be in the longer term the most enduring. Ley's, too, like Jobson's/Qualcast, and also with the incentive of Rolls-Royce, expanded into supplying the motorcar industry in the early twentieth century. The foundry closed after a takeover in 1986 and has since been largely demolished.

One specialist foundry, Haslam's, Little Chester, started life in 1868 when William and Alfred Haslam (1844–1927) acquired the premises of James Fox's machine tool firm (*see* Regency and Railway chapter) and neighbouring Peach's Union Foundry. Sir Alfred (as he became in 1891) was not so much an innovator as a gifted exploiter of others' innovations, added to commercial acumen of a high order. Haslam changed from heavy engineering and boiler making to participate in a race to develop the first commercial dry-air refrigeration plant to be put into ships to enable the import of frozen meat from the New World or South America. He collaborated with two London firms, took both over, and by 1871 had

Ley's Foundry in decay, September 2006. (Author)

HQ of Ley's/Ewart Chain Belt, with works behind, July 2007. (Author)

Sir Alfred Haslam knighted on Derby Station, May 1891, from the ILN. (Author)

installed his first plant in the new steamship *Cuzco* (Orient Line) on the Australia run, beating French rivals by a whisker. The *Cuzco* was able to bring 17,000 lamb carcases back, and Haslam enjoyed a virtual monopoly until 1894. Haslam's also supplied many land-based institutions with refrigeration plants like docks, asylums hospitals, barracks and hotels. The works, which were continually expanding into the Edwardian era, were driven by three powerful steam engines and in 1891 employed 650 hands, nearly all of whom were housed in Little Chester, which Haslam transformed into a company fiefdom. The factory itself was shielded from City Road by a blind arcaded wall, which eventually ran to forty-four bays. He provided superior housing in Little Chester for his workforce and a recreational building opposite with library and canteen. It was taken over on Sir Alfred's death in 1927 by Newton Brothers, electrical engineers, and from 1939 by E. W. Bliss (UK) Ltd., a US firm that specialised in the manufacture of the very tin cans that Haslam's inventiveness had eliminated. They also, however, made hydraulic presses, but the firm closed in 2004.

Another family member, Edwin, succeeded to Sir Alfred's brother William's business. William had revived the craft of ornamental wrought ironwork in Derby, which Edwin continued in a workshop in St Helen's Street, right next door to the Marble Works, using a timber-framed shop in Iron Gate as a showroom, and the name in brass letters (now painted over) is still visible on the lower facia. He was also a gas engineer and maker of brass light fittings as well as ornamental wrought iron, and with the coming of electricity to Derby in 1893, he also became a pioneer of electroliers and domestic lighting.

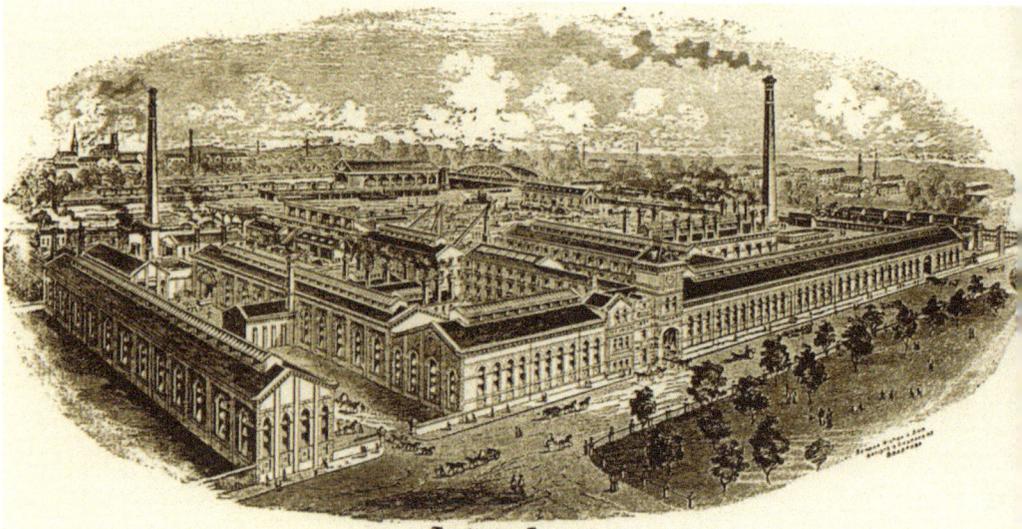

THE UNION FOUNDRY.
DERBY.

Above: Haslam's Union Foundry, Little Chester, 1910. (Author)

Left: City Road, Union Foundry wall, February 2016. (Author)

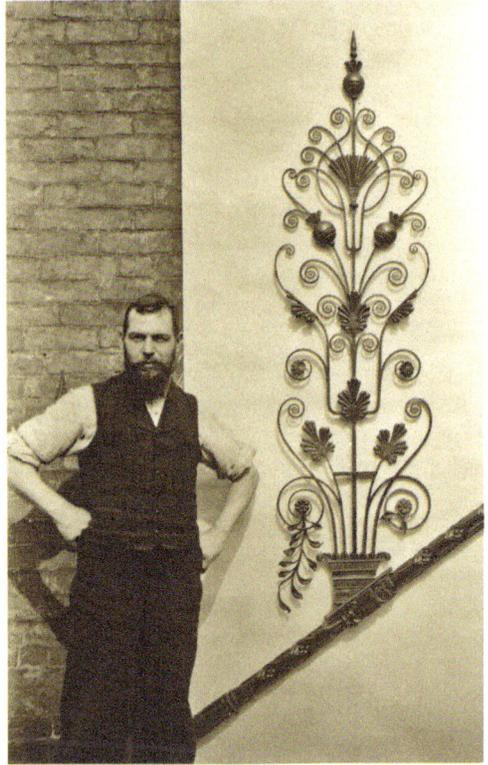

Edwin Haslam posing with an example of his handiwork, 1882. (Late Anne Haslam)

Haslam's shop in Iron Gate, 1988, once home to John Whitehurst II. (Author)

In all, there were no less than sixteen iron and specialist engineering foundries flourishing in Derby by 1891, whereas there were only a dozen or so firms specialising in the manufacture or preparation of fabrics – silk, narrow tapes, uniforms and lace – along with two firms of specialist dyers, so textiles continued to flourish, especially silk.

Bath Street mill, near Handyside's foundry and next to the river, was the last purpose-built factory for silk, erected in around 1848 by Alderman George Holme (1813–96). Its three-storey pedimented façade was extended from twelve to thirty-two bays in 1868, despite the fact that the silk industry was in terminal decline. This was because in 1860 the Anglo-French Cobden-Chevalier Treaty had been ratified, which removed protective tariffs, which had allowed English silk throwing to flourish since the industry began with the Lombes. The treaty plunged the UK silk throwing industry into sharp decline and saw the closure of several Derby firms. George Holme's mill, though, had anticipated the move, diversifying and becoming the first to produce silk elastic web on power looms and, by 1859, was employing between seventy and eighty hands out of the 6,000 or so then employed in silk in the borough; hence the move to expand the operation in 1868. By the 1880s there was a further diversification into the manufacture of woollen serges and lastings and, by 1891, there were almost 300

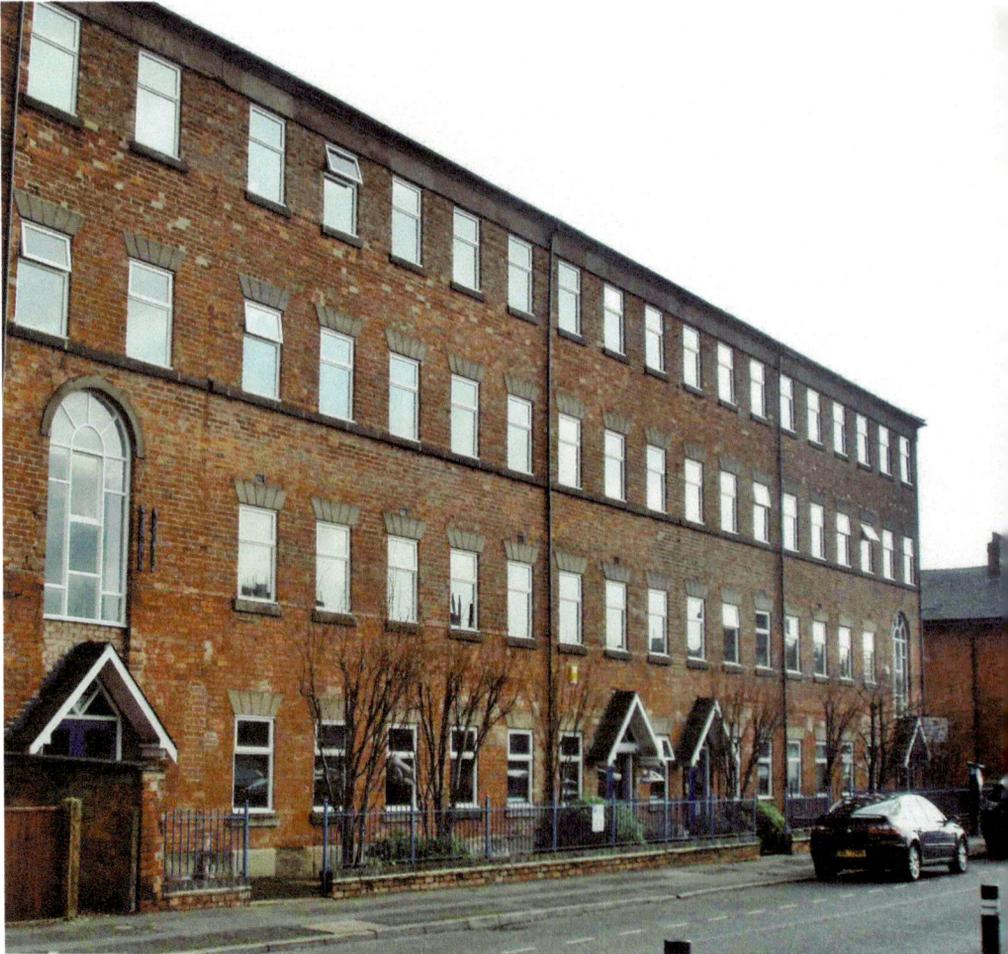

Castlefields Mill, Canal Street, 1836, once Turner's steam silk mill. (D. Maltby)

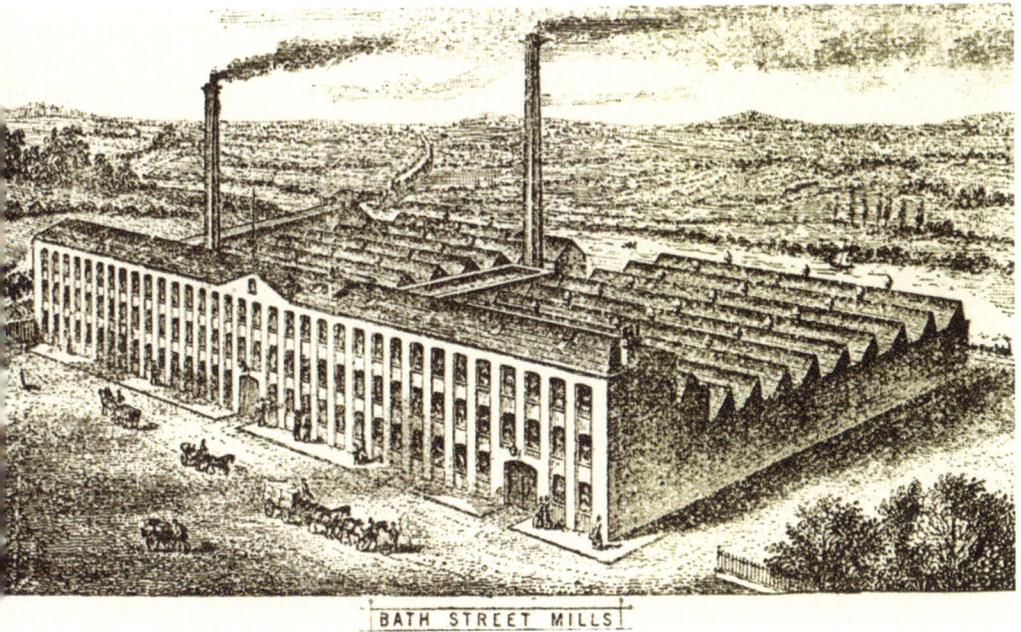

BATH STREET MILLS

Bath Street Mill from a 1891 advertisement. (Author)

employees, although the firm was sold at the beginning of the new century and the mill became a cotton mill. George Holme's guiding principle in life, apparently, was 'a maximum of work with the minimum of words'! Sadly, the long empty mill, due to be reinvented as apartments, mysteriously burned down in June 2009 and was completely destroyed, a happenstance which much facilitated the planned redevelopment.

The silk industry in Derby, therefore, by 1860 was effectively extinct except for firms making silk goods. Other industries looked doomed in the nineteenth century, too, like porcelain manufacture, another of Derby's luxury trade industries. The Nottingham Road factory declined after having changed ownership from the younger William Duesbury at his death in 1793, to Michael Keene (who sensibly married his widow) and from him in 1811 to Robert Bloor. The firm began to go downhill when Bloor (like the younger Duesbury) began to become mentally impaired and in 1846 his niece Sarah and her husband Alderman Thomas Clarke, a wealthy maltster, installed Samuel Boyle of Stoke as proprietor, but bankruptcy loomed, upon which they closed and demolished the factory in 1848, allowing Alderman Clarke to build vast maltings upon the site, a development underlined by the fact that Derby in the 1890s still hosted two large malting companies and four major breweries.

Nevertheless, that same year the china factory closed, a group of employees under W. G. Larcombe migrated to premises in King Street, and founded the Old Crown Derby China factory there. The best period of this well regarded but never large firm was under Sampson Hancock 1863–98. After his era, in the earlier twentieth century, it passed into less determined hands and succumbed to the economic depression in 1935, being acquired by Royal Crown Derby and closed down, although most of the kilns and workshops survived until 1987.

The Royal Crown Derby factory, it may be added, was a late addition to the stock of Derby's luxury trades, having been founded beside the arboretum in the redundant Union Workhouse in 1878, but went on to become a major player in Britain's china making. Its takeover of the King Street factory also endowed it with a thread of continuity going back to 1750.

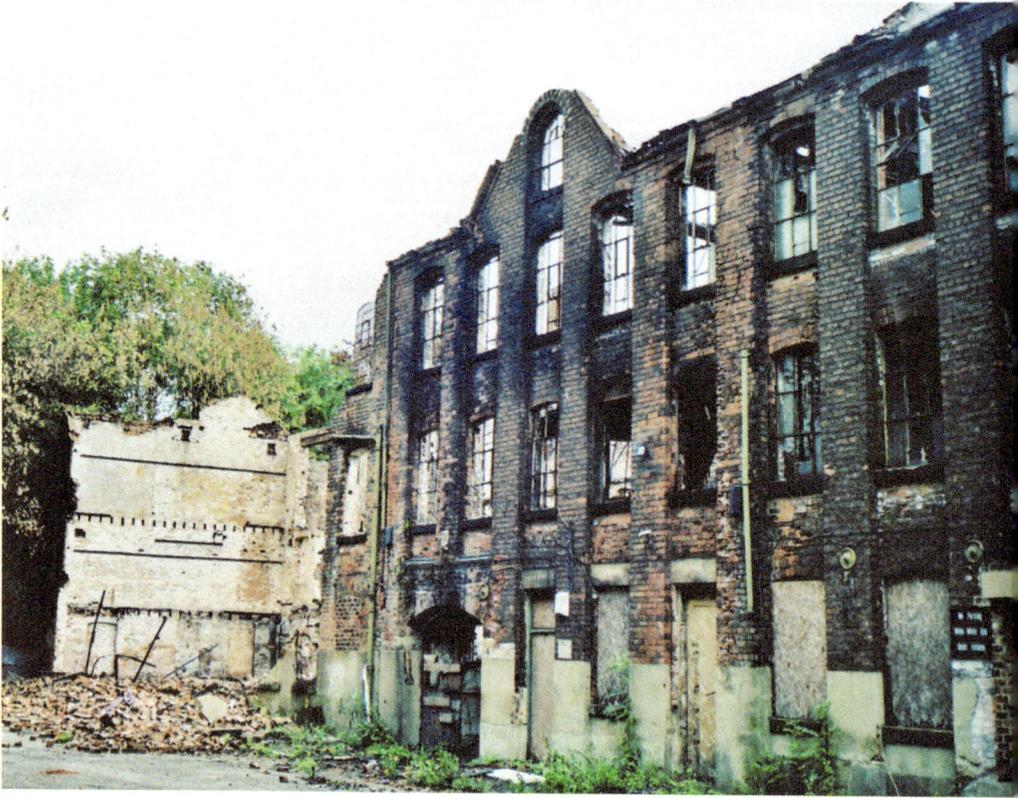

Above: Bath Street mill after the fire, June 2009. (Author)

Left: Bloor Crown Derby plate of *c.* 1819 with a view of Darley Abbey mills. (Mellors & Kirk)

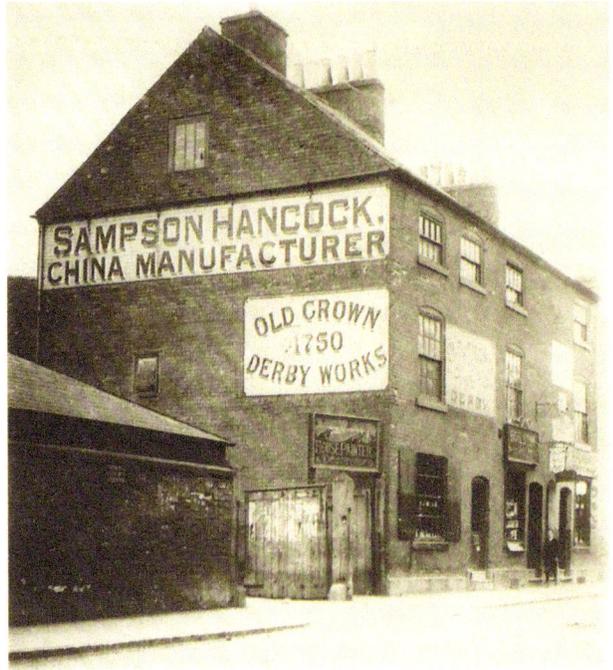

Right: King Street china factory entrance, *c.* 1937. (Late Mrs. W. Moore)

Below: View of Derby Bridge Chapel on Sampson Hancock plate. (Bamfords Ltd)

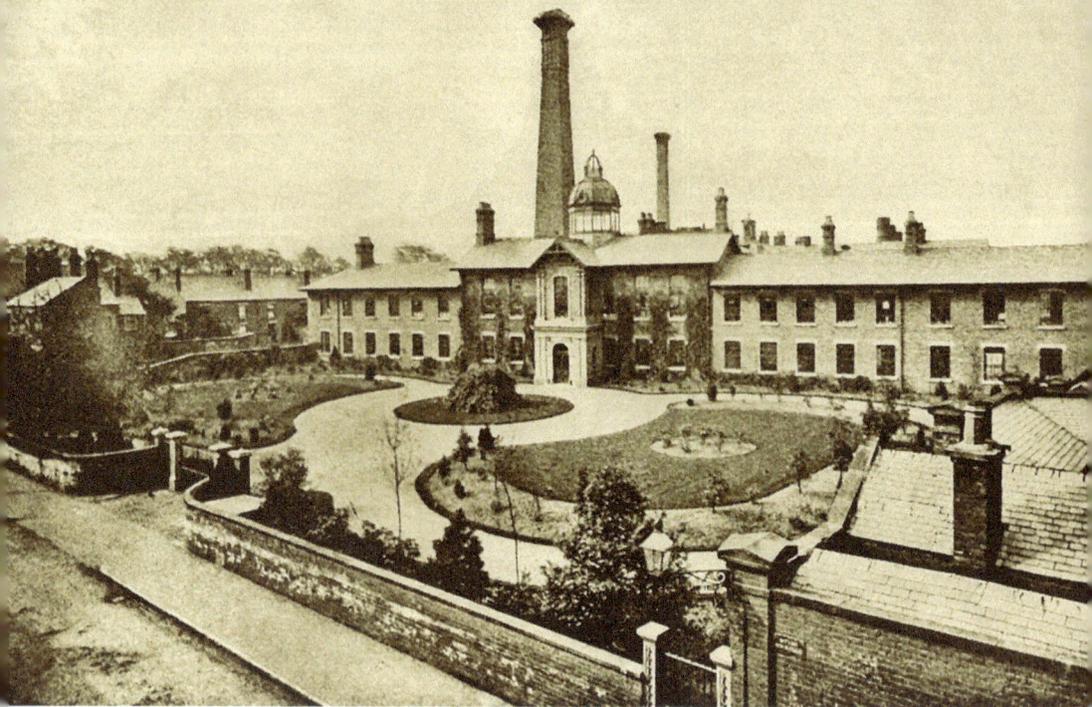

Royal Crown Derby Works, c. 1900. (Author)

MODERN TRANSFORMATION

U ntil the outbreak of the First World War only one significant addition was made to Derby's industries. This was Rolls-Royce, which was to have far-reaching effects on Derby in many ways. It was also Derby's first car manufacturer, but was not to be the last.

Essentially, Royce's was just another foundry. The firm had begun in Manchester where Henry Royce had an electrical engineering works, but by 1904, dissatisfied by those he had seen, he had built his own car. That year he met aristocratic Welsh car enthusiast and dealer Charles Rolls, and they developed a very superior large car by 1906, the year they incorporated the company, and in 1907, enticed by the offer of cheap electricity, moved to a 13-acre site on part of what had been the Osmaston Hall estate. Here the works, largely designed by Royce, was built by Andrew Handyside & Co.

Sir Henry Royce, Hon. Charles Rolls and the Civic Society plaque. (RR Heritage Trust)

Left: Former Rolls-Royce HQ, Nightingale Road, June 2016. (Author)

Below: Silver Ghosts being built, Royce's No. 1 shop, January 1912. (Late Olga Fraser)

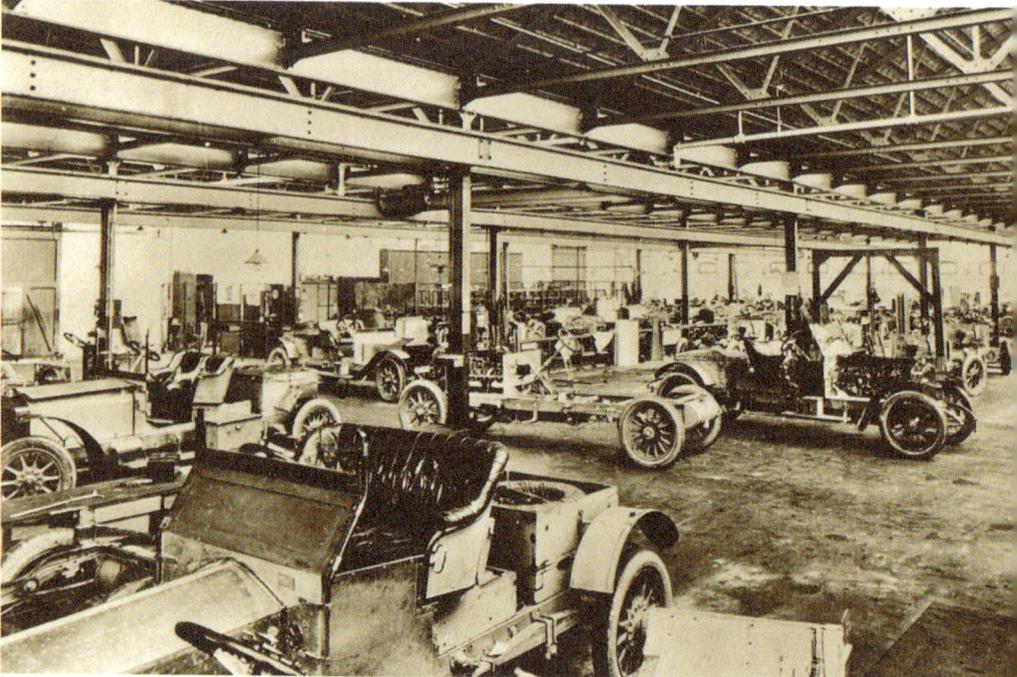

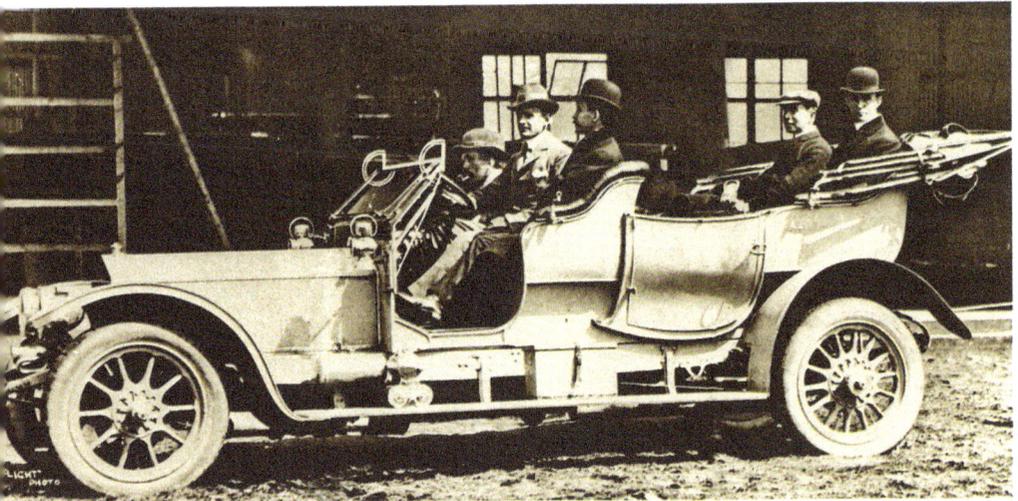

Charles Rolls, Horace Short and the Wright Brothers in a Silver Ghost, Sheppey, 1910. (RR Heritage Trust)

Royce's 40/50hp car, later called the Silver Ghost, was the result of his persistent quest for perfection. Rolls's association with Horace Short and the Wright brothers from 1909 led him to suggest that Royce apply the same level of perfection into developing an aero engine, those then available being less than reliable. Henry Royce, however, demurred, a decision reinforced in his own mind by the tragic death of Charles Rolls in a flying accident at Bournemouth in 1910 aged thirty-two.

However, with the outbreak of the First World War, and with a certain amount of prodding from figures in the government, he changed his mind, and began developing aero engines and their Eagle was the best of its kind during the conflict and afterwards. The firm also adapted the 40/50hp chassis as armoured cars.

Development continued after the war with cars, including smaller models than the Phantom I, the Silver Ghost's replacement, and in 1931 Rolls (the correct way to identify the car, rather than the firm) bought out Bentley Motors and the two marques remained essentially united until 2002. Aero-engine development was impressive meanwhile, impelled by success in the Schneider Trophy seaplane speed trials in 1929–31 and, by 1936, the Merlin engine was a world-beater, going on to power many of the most successful Second World War aircraft, including the Spitfire, Hurricane, Lancaster and Mosquito. They and their successors were built at Derby and elsewhere in the country, while car production stopped, moving out of Derby at the end of hostilities.

The coming of Royce's, like that of the MR, attracted a host of firms able to supply castings, mouldings and components, although Derby was home to many such already. Yet the firm, driven by wartime necessity and the rapid development of civil aviation, afterwards became Derby's major employer, moving out to a vast new site at Sinfin and by 2010 its original site was largely cleared, except for the old administrative building and its later centrepiece, called the Marble Hall (1936–37), preserved by a last-minute Grade II listing.

There were hiccoughs along the way. In 1971, the development costs of the RB211 fanjet engine overran so badly as to force the firm into receivership and the Conservative government, overcoming its scruples, nationalised it rather than see it broken up and to save jobs. It was returned to the private sector in 1987, and has flourished since. It also has a

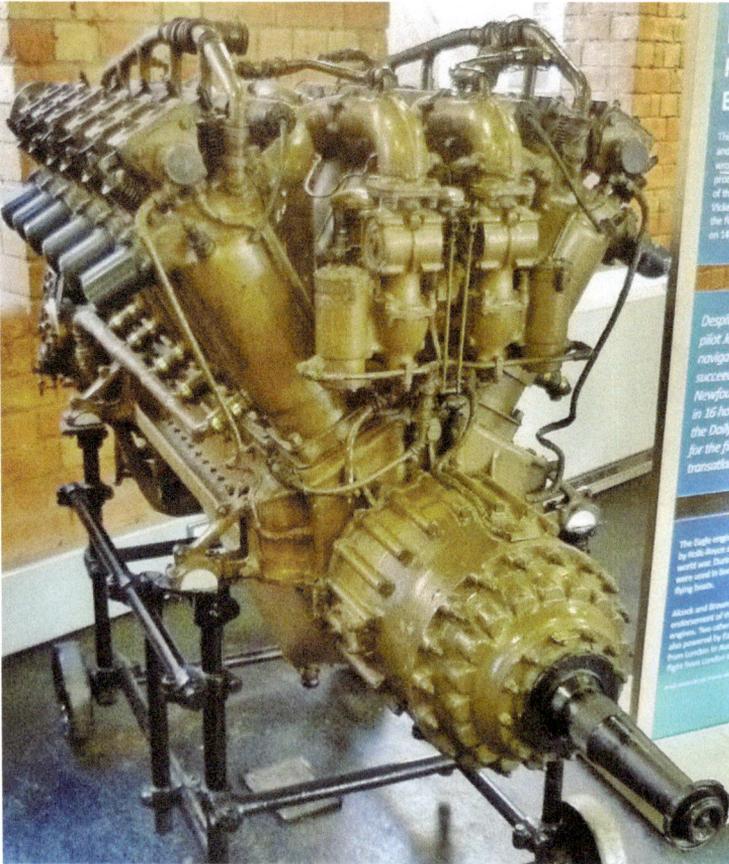

Left: Rolls-Royce Eagle engine in Derby Museum, the Silk Mill, April 2017. (Author)

Below: Mosquito VI Merlins of 605 Sqn RAAF loom over B flight, Castle Camps, August 1944. (Author)

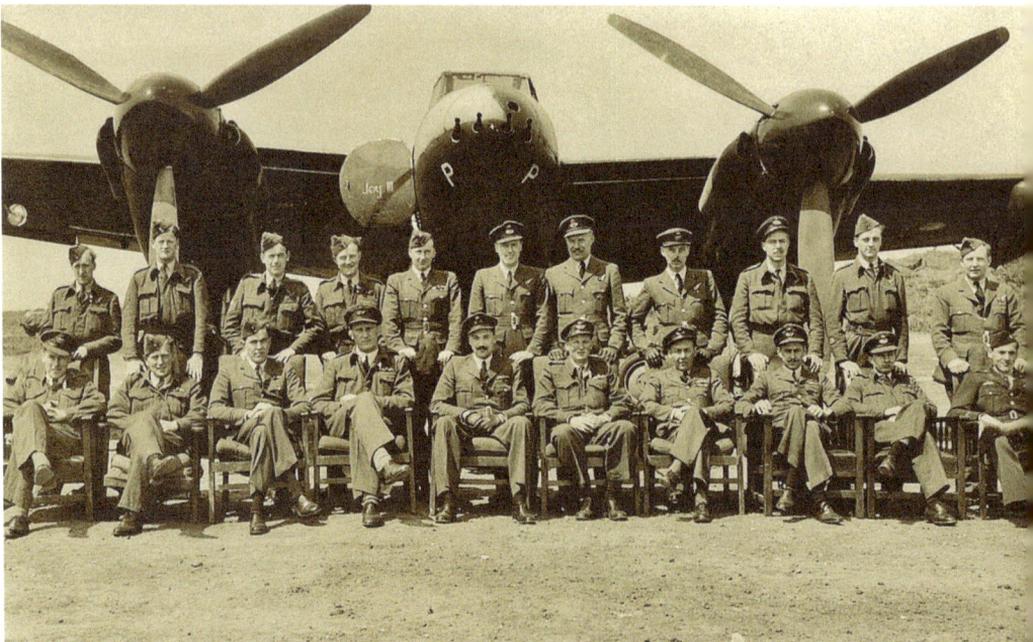

Rolls-Royce's current HQ and Sir Henry's statue, Wilmore Road, Sinfin, April 2017. (Author)

Rolls-Royce's 1938 Marble Hall as restored, June 2016. (Author)

separate company, now Rolls-Royce Marine Power, founded as Rolls-Royce & Associates on Raynesway in 1960 to build nuclear reactor cores for the navy. This led to much mirth in 1982 when a radical left-wing county council declared Derbyshire a nuclear-free zone – clearly in complete ignorance of the firm's business!

Yet while Royce's generally flourished in the twentieth century, the core heavy industries of the century before failed to survive. Railways, especially, changed a great deal. In the First World War, the works at Derby and elsewhere turned their hand to the manufacture of munitions and other war requirements, with workforces generously topped up with women and the entire operation overseen by the MR's locomotive superintendent Henry Fowler, who received a knighthood for his pains, buying Spondon Hall on his subsequent appointment as chief mechanical engineer of the London, Midland & Scottish Railway (LMS), into which the MR had been absorbed at the grouping in 1923.

The LMS chairman, Lord Stamp, was a great believer in training, research and development and the firm gave Derby two magnificent *moderne* buildings: the Railway School of Transport at Wilmorton by W. H. Hamlyn, with murals by Norman Wilkinson, and the LMS research laboratories, London Road, by H. J. Connal. The former, now splendidly restored as a conference centre, contained a 45-foot gauge 1 electric model railway to teach signalling, unforgivably ripped out in the 1960s.

Nevertheless, the paramountcy of the railways and the requirements of another world conflict (Derby works making aircraft rather than shells this time) kept all the old MR facilities in full flow after the grouping and remained so until they suffered nationalisation in 1948, when 'rationalisation' kicked in. This was exacerbated by the BR 'modernisation' programme starting in 1957, when steam power was officially abandoned (ending in 1968) in favour of diesel and electric power, mainly supplied by outside contractors.

Rolls-Royce Marine Power factory, Raynesway, 2013. (Frank Shaw Associates)

Right: Sir Henry Fowler FRS by Ginsbury. (Author)

Below: LMS School of Transport, 2011. (Author)

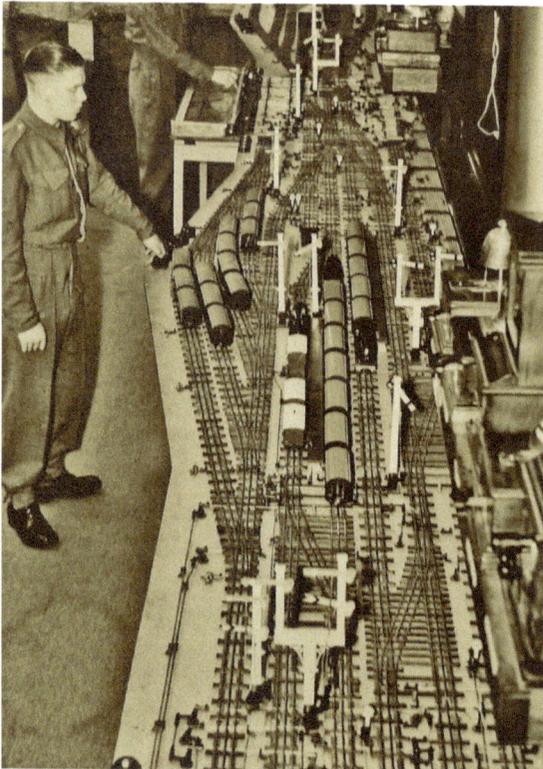

Above: Transport murals in the hall of the School of Transport by Norman Wilkinson. (Author)

Left: School of Transport gauge 1 layout, in use by men of RE (RoD), 1942. (Author)

Former LMS Labs, London Road, April 2017. (Author)

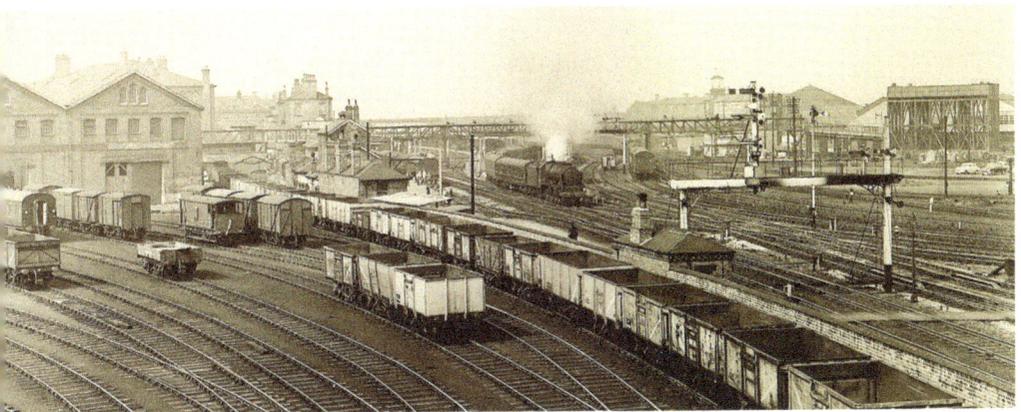

Derby station, south end, by Frank Scarratt, October 1959. (Author)

From this time the works began to lose contracts, and parts were progressively closed, although the quality of the research establishment set up in LMS days and actually built up in the 1960s in order to facilitate, among others, development of the HST and APT 'tilting' train, ensured this aspect largely survived and continued to flourish, trebly so after de-nationalisation from 1996. Today, under the ownership of Bombardier Transportation (not pronounced in the British manner, due to being a Canadian concern), the works occupy a physically far smaller area, but have recovered viability and lost prestige. Mercifully, amid all this change, the old pioneering MR buildings survived and are now restored and incorporated into Derby College.

Bombardier works, Derby, from London Road, April 2017. (Author)

The decline that affected railway engineering affected the foundries badly, made worse by changes in domestic economy, wherein demand for stoves, radiators and boilers were in sharp decline too. Although there were some exceptions, like the pipe-making foundry of Sir John Aiton on Stores Road (for which his architect daughter Nora designed a bravura *moderne* HQ building in association with Betty Scott), in the 1960s and 1970s a series of amalgamations and closures took place, with swashbuckling entrepreneurs like locally born Sir Nigel Rudd's Williams Holdings buying up failing companies, closing them down and selling the sites for redevelopment. In the end, even Aiton's suffered this fate, although one of the most advanced, International Combustion Ltd (to Derby in 1922), a supplier of power station boilers, was bought out by Royce's in 1990 for its expertise and 22-acre adjacent site before being sold on seven years later.

Other industries also declined. Narrow tapes and many of the textile-based works closed, including Longden's, Green's and even Boden's giant lace mill, dynamited in 1960 for a failed shopping centre. The last breweries went, too. Alton's absorbed Stretton's in 1922 and both were gobbled up by Ind Coope & Allsopp in 1927, the brewery closing two years later. Offiler's, the last survivor, was sold to Bass Charrington in 1965 and brewed its last pint in its brewery (previously James Wyatt's 1805 Ordnance factory, later turned into a silk mill) in 1966.

Twenty-five years after the end of Hitler's war, the town (made a city in 1977) dominated by two giant employers – the locomotive works and Royce's – looked doomed to the deepest recession. Yet, in the event, and despite a succession of perpetually blinkered and inward-looking local administrations, diversification gradually came about, saving some old jobs, creating new ones and bringing in new industries and forms of employment. Although Rolls cars forsook Derby in 1946, old Etonian ex-RR engineer Col. Michael McEvoy had built fine motorbikes in small numbers in Derby's West End in the 1920s, and in the 1970s another marque was made in the city. In 1989, Toyota founded a vast plant just beyond the city's western boundary on the former municipal aerodrome at Burnaston, albeit at the expense of a listed country house. The first car rolled off the production line in 1992.

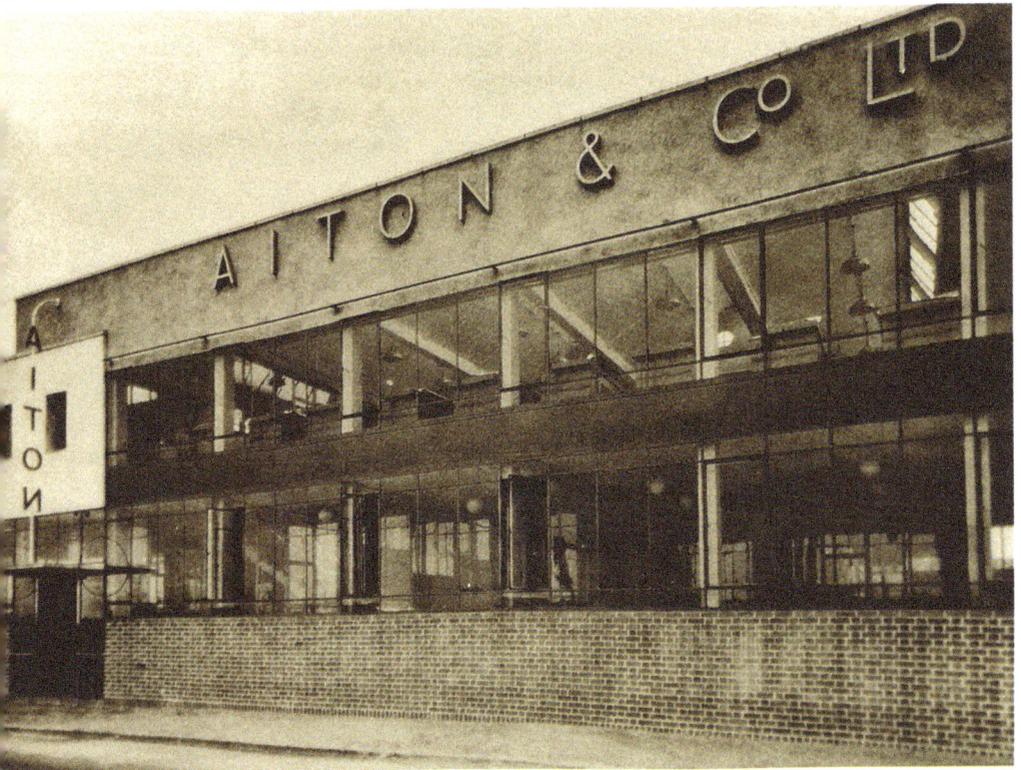

Above: Aiton's offices, Stores Road, when new, 1934. (Derby Local Studies Library)

Right: Agard Street, Longden's Mill, under demolition, 1989. (Author)

International Combustion Ltd advert, 1928. (Author)

Green's Mill by Markeaton Brook, in decay, 1997. (Author)

Left: Offilers' Brewery advertising playing card, *c.* 1930. (Private collection)

Below: A Scarratt view of Derby Aerodrome, Burnaston, with Burnaston House on the right, 1939. (Author)

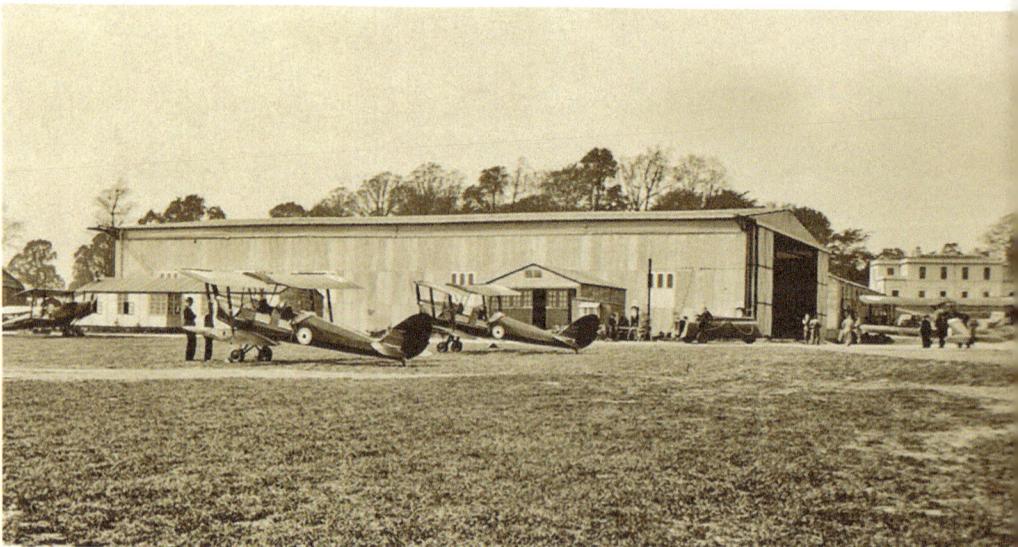

Although Derby's textile industries followed the same pattern as the foundries in its decline throughout the twentieth century, this did not seem likely at first, for in 1916, Courtaulds had moved to a site on the edge of Spondon, then recently vacated by a paint manufacturer, and began production of doped cloth for aircraft, moving rapidly on to making artificial fibres like nylon and rayon. This factory grew to considerable proportions by the post-Second World War era, and was probably Derby's third major employer after the locomotive works and Rolls-Royce. It was by then British Celanese, and its processes led to the emission of a very distinctive odour that polluted the air especially around Spondon for many decades and was known as the Spondon Pong. Part of the site is now dominated by two huge wind turbines erected in 2013 by the Severn Trent Water Co., before they realised their motion would give a false reading on the Castle Donington airport ATC; they have not been used since.

At the same time the narrow tapes mills were declining, their empty premises, when not demolished for redevelopment were being taken over from the 1960s by operations, usually run on a small scale but intensive fashion by Asian families producing specialised fabrics and clothes. The last of the main players was James Smith's uniform factory in Drewry Lane, closed in 1987 after 157 years and, following a series of mergers, Courtauld's factory in Spondon, also closed in 2012, leaving the vast site too polluted for immediate redevelopment, unlike others in Litchurch.

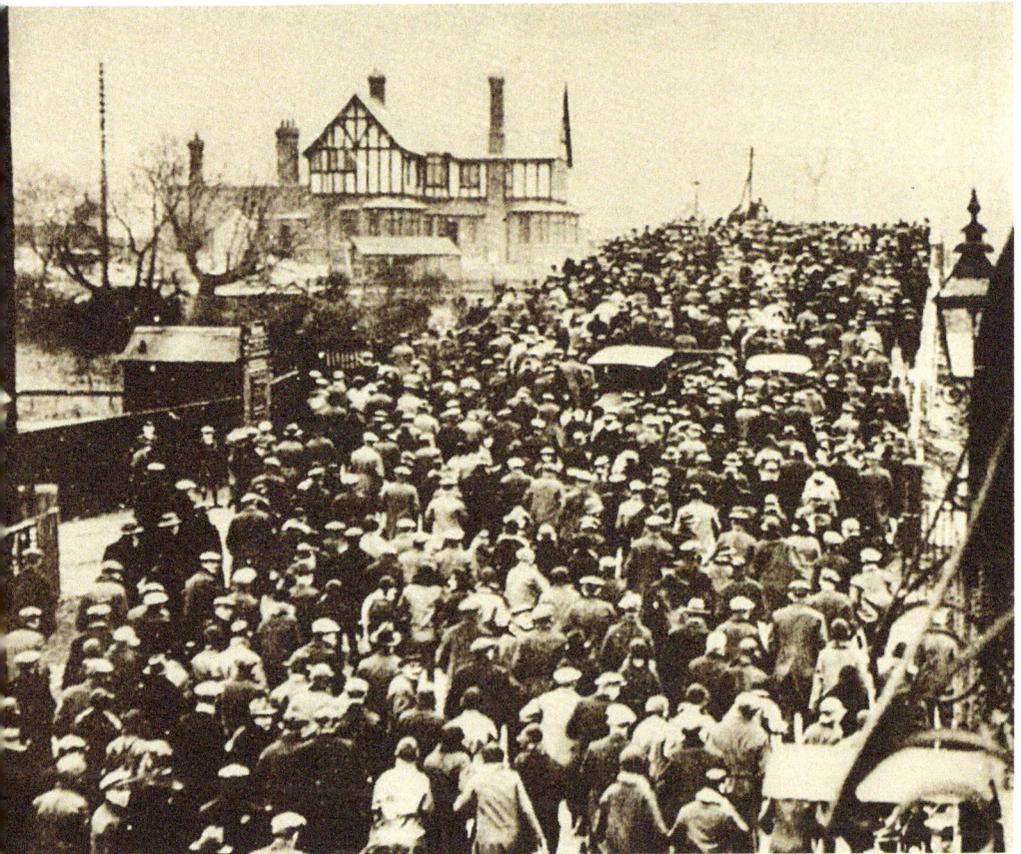

Workers returning from work at British Celanese, Spondon Station, 1930. (DMT)

The very large and very inert Severn Trent wind turbines, Spondon, January 2014. (Author)

Shaftesbury Street after the clearance of the foundries, September 2006. (Author)

Yet, the decline of the traditional industries did not leave Derby a ghost town by any means. The astonishing revival of rail travel in the wake of de-nationalisation had led to a plethora of new concerns undertaking advanced railway research and others developing other aspects of railway engineering, but far from the traditional iron and rivet engineering that flourished under the MR, LMS or BR. There are still firms at the cutting edge of railway technology, and the development of two specialised industrial areas – Pride Park, formed on the reclaimed site of the Litchurch Gas Works, and Infinity Park, in green belt adjacent to Royce's Sinfin campus – has afforded growing space for new concerns coming in. There have also been a number of IT companies based in Derby, including Core Design, which was founded in Derby by nine friends in 1988 and which in 1996 developed *Tomb Raider*, giving Derby its first virtual heroine, Lara Croft, after whom the city has even named part of its new inner ring road.

And, despite all of this change, a core of the luxury industries, which arose in the age of Enlightenment in Derby, have survived and flourished: Royal Crown Derby, the unbroken inheritor of the tradition begun by William Duesbury in the 1750s; Davis of Derby, founded by John Davis to make domestic instruments in competition with John Whitehurst III in 1835, but which successfully diversified into mining and precision instruments; and Smith of Derby, manufacturers of turret clocks and allied architectural products, with an unbroken tradition going back to John Whitehurst FRS, whose grand-nephew and successor employed and trained the first John Smith before he founded his company in Nuns Street in around 1849. Even the Derby Canal, abandoned in 1939 and closed in 1964, is now slowly being restored, albeit on a slightly different course through the town centre, by the Derby & Sandiacre Canal Society.

Derby has, against all the odds, managed to turn inevitable industrial change to its own advantage, aided by a very enterprising and well-connected business community and much in the entrepreneurial tradition of John Whitehurst and the Lunar Society from which it predominantly stems.

Pride Park, AEA building (now RR), St Christopher's Way, April 2017. (Author)

Lara Croft Way looking south-east, May 2017. (Author)

John Davis & Son boxed 8-inch protractor, c. 1875. (Author)

Smith of Derby: clock movement under construction for Toronto. (Smith of Derby)

ABOUT THE AUTHOR

Maxwell Craven was born in London, son of a shipbroker, and was educated in the West Country, but lost his parents in his teens. He obtained a University of Nottingham BEd (Hons) degree and worked in business in London for four years before obtaining a post at Derby Museum, where he remained for twenty-five years, eighteen of them as keeper of antiquities. In 1980, he began to write books, mainly about architecture and local history, including *The Derbyshire Country House* (3rd rev. edn 2001) culminating in his 2015 life of John Whitehurst FRS.

Since 1998, he has combined journalism, researching and producing architectural statements of significance with continuing work for various local and national amenity societies. He is also a consultant for Bamford's Auctioneers and has concentrated on campaigning to preserve historic buildings, urban environments and country houses. He has edited Derby Civic Society's Newsletter for over twenty-five years and that of Derby Museum Friends for seven. He is a long-serving member of the Derby Conservation Area Advisory Committee (chairman 2006–09 and again currently) and Derby Cathedral Fabric Committee. He is also vice-chairman of the Derbyshire Historic Buildings Trust, a member of the Board of Derby Museums Trust and a trustee of Derby Bridge Chapel.

In 1996, the University of Derby awarded him an honorary degree and appointed him to the University's Court; he was further awarded an Honorary D. Litt by the university in 2013. He was elected a Fellow of the Society of Antiquaries of London (FSA) and made MBE in 1999 and elected FRSA in 2016. He lives in Derby with his wife and daughter.